Unless It Moves the Human Heart

Also by Roger Rosenblatt

Unless
It Moves
the Human
Heart

The Craft and Art of Writing

Roger Rosenblatt

An Imprint of HarperCollinsPublishers

HarperCollins books may be purchased for educational, business, or sales promotional use. For information, please write: Special Markets Department, HarperCollins Publishers, 10 East 53rd Street, New York, NY 10022.

FIRST EDITION

Designed by Mary Austin Speaker

Library of Congress Cataloging-in-Publication Data has been applied for.

ISBN: 978-0-06-196561-6

11 12 13 14 15 OV/RRD 10 9 8 7 6 5 4 3 2 1

For Jim and Kate Lehrer,

writers, teachers, friends

The difference between the almost right word & the right word is really a large matter—it's the difference between the lightning bug and the lightning.

Mark Twain

Acknowledgments

Rachel Bressler, Carla Caglioti, Libby Edelson, Rachel Elinsky, Jane Freeman, Dan Halpern, Shirley Kenny, Gloria Loomis, Peter Manning, Robert Pattison, Robert Reeves, Ginny Rosenblatt, Julie Sheehan, Ginny Smith, Martha Smith, Stephen Spector, Adrienne Unger, Lou Ann Walker, Lydia Weaver.

Contents

Preface

Before you read this book, I must confess a fraud. What I present as a word-for-word account of the conversations that went on in my writing classes at Stony Brook University in the winter/spring of 2008 is fiction, top to bottom. I would like to have recalled verbatim all the marvelous things that I and my dozen students said over the course of the semester, but my mind, hardly a steel trap, recalls only the problems and subjects we discussed. To be clear: nobody really said what I say he said in class. But the ideas expressed here were expressed there. The samples of student writings are genuine. And the students themselves were just as gifted, lovable, and annoying as I have drawn them.

Unless
It Moves
the Human
Heart

Us

Jasmine, Inur, and Kristie took my Modern Poetry class last semester. Nina took that class with me last spring. George, Suzanne, Diana, and Veronique took my workshop in novel-writing, also last spring. Of the others in the room, I recognize only Robert, who is a graduate student in our MFA writing program. He also owns two of the better restaurants in the area—Robert's in Water Mill and the Paradise in Sag Harbor. As soon as I spot him, it occurs that I might inveigle him into holding the class party at Robert's, for free. I mention this brainstorm as I call the roll. He maintains an

amused but noncommittal expression. Ana, Donna, and Sven, like Robert, have not taken classes with me before and appear both more polite and more apprehensive than the others. I try to make everyone feel as uncomfortable as possible.

"Why do you want to take this class, Jasmine?" I ask the twenty-two-year-old. "To learn to write like John Donne?" She smiles demurely. Last semester, in Modern Poetry, she piped up out of the blue: "I don't like John Donne." In forty years of teaching literature and writing courses, I had never heard anyone say such a thing. This slight, composed, reserved graduate student, with the high voice of a little girl, had assaulted the sacred. "He has nothing original to say," she said. I told her, "Even if that were so, don't you think he gets credit for the way he said it?" She looked away, faintly bored. I hated to admit that she may have had a point, which still will not prevent me from needling her from now on.

This course I call Writing Everything. My students spend the term writing a short story, an essay, and some poems. We meet once a week for two hours. The original idea of the course was to determine the principal strengths of each of the forms, then see how each might be of use in writing any of the others. Most MFA students plan to write fiction, so I thought that, in addition to short stories, they would profit from trying poems, to concentrate on original language, and essays, to develop ideas. It turned out that those expectations were too

rigid, and I learned it was better to say less about the individual properties of the forms, and simply allow the students to enjoy writing something different.

They sit at the seminar table in a classroom at the Stony Brook Southampton campus, on eastern Long Island, writing pads before them and pens poised, on the chance that I might say something interesting. It is the last week of January 2008, the beginning of spring term. The room, a cubed trapezium made up of sharp corners and angles, is a little too bright, with floor-to-ceiling windows that admit the fierce winter sunlight. Even on cloudy days the white walls and the white tiled ceiling reflect light. The floor is gray, with a design of little sand-yellow squares. Two long egg-box cases of fluorescent bulbs hang from wires ten feet above the seminar table, also white. The table is composed of four smaller tables pressed together in a rectangle, about six by twelve feet. I sit at one end with Kristie beside me. I think she has claimed the position for purposes of hectoring. George and Suzanne, husband and wife, sit at the opposite end, with the others arranged four on each side of the table. Twelve is a very good number for a writing class, as it is for juries and apostles. The chairs, some type of plastic, are construction-paper blue. There is one blackboard—green in this case—behind me, and another on the wall to my left. Occasionally faint hammering and the whine of an electric saw can be heard from outside, as this, the newest of the Stony Brook University campuses, is still

being worked on. But the room has a quiet feel, and something about its aggressive sterility works in favor of creative minds.

"Isn't this class supposed to meet for *three* hours?" asks Ana. "That's what it says in the course catalog."

"It does say that. But I can't take the sight of students for that long. Even two hours is stretching it."

"We'll report you to the dean," says Sven.

"Please do. But if you would like to stay here for three hours every week, be my guest. I leave after two."

I have a good feeling about this class. I'm going to like them. Liking a class is more practically useful than it sounds. In a likable class, discussions are freer, more open. When the students like one another, they take everyone's work more seriously. In another class I taught, after a woman read a section of her novel aloud, another woman asked, "May I be your friend?" The first woman answered, "You already are." The students will also feel safe with one another, and will trust the group with personal information they use in their writing. In my novel-writing workshop, a student wrote about a woman who was taking care of her husband, whose mind was deteriorating. She too was deteriorating from the effort. She told her story as a novel, but the students understood it was her own. They respect such disclosures. They unite with one another like a noisy brood of brothers and sisters. And they can always unite against me.

"What if we stay for the third hour and discover we don't need you?" asks Robert.

"Win-win."

Sometimes they protect one another. One of the first things teachers learn to look for in students' writing is the subject of suicide. A student in that same novel-writing workshop ended his book with the hero walking into the ocean after having slit his wrists with seashells. A woman in the class came to my office hours to say she was concerned about the suicide ending. Did I think something was troubling the student? I talked to him after class, and he seemed fine. But the impressive thing was his fellow student's alertness, which stemmed from affection. Writing programs do not actively promote such careful attentiveness, but the fact that every life counts is built into the work we do. I think the students pick up on this.

This year's group come from very different backgrounds, and are widely diverse in experiences and in ages. All this should make them more interesting to one another. I remind them that they comprise the only audience of readers they need worry about for the present. They will read one another's work, and comment on it. I want them to know, "You'll never have a situation like this again. Writing is a lonely enterprise. Here, in these classes, you have colleagues, people who share everything with you and wish you well." I urge them to be severe and exacting in their comments. "I'll never let

you be harsh, though I doubt you ever would be. And I promise: in all my years of teaching, I've never had to referee a fistfight." This is a half-lie. Some years ago I had a really good student writer, a kid from the streets, who was built like a frozen roast and rode to class on a Harley. He could not take criticism, and fought with me over every correction I made on his work, beyond the point of reason. Years later he sent me a letter allowing that I may have been right about a thing or two. But there was one class meeting where things got so hot between us, we nearly came to blows, which would have been bad news for me.

Donne-hating Jasmine grew up in Babylon, Long Island, went to Stony Brook as an undergraduate, and by her own admission, has had no experience in anything. Her mother is from St. Lucia, her father from Hempstead, New York.

Inur's family, originally from Uzbekistan, settled in Pakistan, then emigrated here. She is twenty-four, Muslim, beautiful, and a terrible reader of her own work. Every sentence turns up in a Valley-girl question. I kid her about this without mercy, but it doesn't help.

Kristie, who also grew up on Long Island, plays the flute and has worked at a farm stand. At twenty-two, she still looks like a sweet and gawky schoolgirl. She bubbles with life, asks questions unremittingly, and describes herself, inaccurately, as my biggest pain in the ass. Kristie, Inur, and Jasmine are very tight. After the

Modern Poetry course last year at the Stony Brook main campus, the three of them followed me to Southampton. I ask them what I did wrong. They gang up on me whenever there's an opening.

Suzanne, in her early sixties, is slim, with a narrow face engulfed in flaming red hair. She was reared in the Canarsie section of Brooklyn in a neighborhood of Quonset huts, and still has Brooklyn in her voice. Born to a nonreligious Irish family, she became a practicing Catholic on her own.

Her husband, George, fifty-nine, has the body of a pro-football nose tackle, his girth held in check by his six-foot-two-inch height. He dresses in black. George grew up in a German Catholic community. A year and a half ago, while tracing his lineage, he learned his family was Jewish. In the 1930s, they had converted for self-protection. "Of course we're Jewish," relatives told him casually at a family gathering. "Everyone knows that!"

Sven, thirty-three, was reared by his mother, an Austrian. His father, from Norway, died when Sven was two. Sven is reserved and solid, the sort of guy you want on your side. After graduating from the Air Force Academy, he spent five years as an Air Force pilot, flying C-17 cargo planes into Iraq and Afghanistan. As a kid he studied art.

Ana, seventy-one, is petite, with short dark hair and dancing eyes. She was born in London and reared in Argentina, before her family moved here. Her father was

a UN diplomat. She speaks with an aristocratic intona-
tion, but is no snob. She went to Smith.

And there is fifty-four-year-old Robert, who is
blue-collar handsome, like Dana Andrews. His solemn
expression accompanies a quiet wit and a sardonic sense
of humor. His family is rooted in Long Island, though
now he makes his home in Manhattan with his girl-
friend and their nine-year-old son, and commutes to his
restaurants. He has worked in the business since leaving
Queens College, and writes articles on golf on the side.

And Diana, twenty-three, who was a varsity gym-
nast at SUNY Cortland. Bright-eyed, with black hair
and a clear, clipped way of speaking, she is everyone's
pesky, adorable kid sister. She is five feet tall and boasts
that she can high-jump four feet, eight inches. She is
working on her first novel, begun with me last term.

And Nina, fifty-seven, small and graying, with a
lovely, scholarly look. She went to Bucknell, got her
MLS at NYU, and became a librarian. Her mother was
Swiss. Her father, Italian, was the son of a Pennsylvania
coal miner. She took care of her parents at the end of
their lives. Nina is what John Steinbeck calls an "inside-
herself woman." In the Modern Poetry class, she wrote
a brilliant paper on Seamus Heaney in the form of a
parody of a Heaney poem.

And Veronique, forty-three, who went to American
University, and is a former photojournalist for the *New
York Post*. Her parents came here from France and she

grew up speaking French. She has French eyes, mixing wisdom and anxiety. Her fellow students know her to be gracious and kind.

And Donna, forty-nine, efficient, with a pretty and purposeful face, who majored in philosophy at Stony Brook, and got her degree while her three children were growing up. As a young woman, she worked for Izod and Ralph Lauren. She sketches, and gardens. She wants to write essays on the environment. Her husband sells golf balls.

Who among them will turn out to be the better writers? Who will have a voice like no other's, an original stance, a different way of apprehending the world? And who will have the patience and stamina, the seriousness of purpose, to make the most of his or her gifts? Who will recognize that writing is hard labor, *work*? When I started teaching writing courses in my twenties, as the Briggs-Copeland Instructor at Harvard, there were students in my class whose successful futures seemed assured because they had both talent and will. Frank Rich, Mark Helprin—I hardly taught them as much as I stood back and cheered. Yet there was one young woman, the daughter of a federal judge, who was better than the lot of them, born with perfect pitch of language and the quiet authority of Anne Tyler. Like Tyler, too, she had something to say. Yet, for whatever reasons, she did not want to be a writer. Writing was just something she did well. Years after she studied with me, I bumped

into her in a supermarket in Cambridge. "Did you keep up the writing?" I asked her. She shook her head without apology. "You were my most talented student," I said. She smiled and shrugged.

So here we go again—another writing class, like tens of thousands occurring around the country. While programs in English literature have withered in the last twenty-five years, because of a useless competition of various critical approaches, and also probably to an exhaustion of the material, writing programs have burgeoned. Since 1975, the number of creative writing programs has increased 800 percent. It is amazing. The economy has tanked. Publishing favors nonfiction. Young people seem to prefer the image to the word. Yet all over America, students ranging in age from their early twenties to their eighties hunker down at seminar tables like this one in Iowa, California, Texas, Massachusetts, New York, and hundreds of other places, avid to join a profession that practically guarantees them rejection, poverty, and failure. All who have taught in our program—Jules Feiffer, Billy Collins, Meg Wolitzer, Robert Reeves, Ursula Hegi, Marsha Norman, Frank McCourt, Lou Ann Walker, Patty Marx, Melissa Bank, Matt Klam, Kaylie Jones, Julie Sheehan, David Rakoff, and others—dutifully remind the students of their likely fate, but they come to us in hordes anyway.

I look around the table at my dozen hopefuls, a *Chorus Line* without a star to support—smart, good-

natured, talented people who yearn to forge a life from their imaginations. Writing students look different from other students. No matter how old they are, they have a childish romanticism to them, as do professional writers—sometimes self-destructive, but also touching. Ana, sophisticated as she is, has the face of a young girl about to take in her first Broadway play. George, big as he is, looks like a puppy eager for approval. They all want the world of writing so very much—not only to succeed in it, but to be part of it, to stroll in it and feel it wrap around them. I admire their brash impracticality and wonder if, in some way, their reckless enthusiasm for art, conceived and nurtured in an increasingly money-driven age, represents their unconscious protest against the age. I never heard my students say such a thing, or indicate in any way that they thought themselves heroic for beating oars against the tide. If anything, they make a show of bemoaning the lovely madness of their desire. Yet there are so many of them—the continuing multiplication of all the nation's writing programs—I can't help but think that something deliberate and stubborn lies behind their decision to make artists of themselves. They turn to the power of their powerlessness, not unlike Václav Havel, Milan Kundera, Ludvík Vaculík, and the other writers of the Eastern Bloc who had nothing but words to rebel with.

Can I teach them to become professional writers? No. Can I teach them to write better than they do? Yes.

"We will do short stories first," I tell them. "Then essays and poems."

"I haven't written as much as others here," says Ana. "Could you talk about the difference between a short story and, say, a novella, or even a novel—other than length?"

"A novella is essentially a long short story, with a little more happening in it, usually. But a novel is quite different. A novel, being the broad canvas, gives you the development of things—of characters, of action and theme. The business of a short story, on the other hand, is usually over by the time the story begins. That is, you know the character and his or her situation from the opening. You even know what's likely to happen. The story is about why what you know matters."

Writing teachers relish basic questions such as "What's a short story?" because they force us to slow down and consider things part by part. Many years ago, I had an undergraduate, an engineer, who did not know what a story was. So steeped was he in math and science, he could not comprehend the fact that he had seen stories every day and had been living them all his life. Once we began, he felt out of his depth and wanted to quit the class. But I urged him to stick it out. His natural lack of sympathy with the subject made him useful to every discussion, like an annoying member of the audience of a play who shouts out over and over, "I don't get it!" When he would question the simplest idea, I had to

backtrack before we moved on. "What's character?" he would ask. "What's a motive? A character trait? A crisis? What's irony? I don't get it. That's ironic?" At the end of the term, he wrote a complete short story—nothing great, but the parts were there. I doubt if my engineer ever wrote one again. But for the time I knew him, he was my most valuable student.

Before this class gets to writing their personal essays, I know they will ask what the difference is between an essay and a short story. And I'll tell them that an essay deals with something that really happened. And they'll ask, "Can't a short story be about something that really happened?" And I'll say, "Yes, but in fiction you treat facts differently. You dream into them and make them works of art." And they will say, "But there are beautiful personal essays that give facts an artistic feeling." And we'll go back and forth like that and compare examples of each form and understand why the pig or the moon a writer has imagined is different from one he's actually seen. And I will tell them what Shelley said in his "Defense of Poetry"—that we must learn to imagine what we know, and that that applies to fiction and essays as well as poems. And the discussion will be painstaking, but in the end we'll be grateful for the original question that led us to examine the essential elements of both forms. You can't be too clear—especially when trying to teach a subject as murky and intuitive as writing. The poet Tom Lux, who has taught in our summer program,

told his students that poetry is mixed feelings expressed clearly.

"Would you say something about how many drafts one should expect to do?" asks Veronique. "I hate finishing a first draft of a piece because I know it's just a first draft. There'll be a second draft, and a third . . ."

"And a fifth, and a ninth. That's the way it goes. Which is why our first drafts, and probably our second and third, ought to be written in pencil or ink. It's better for us to cross out the wrong words or phrases or sentences, and be able to see the wreckage by the side of the road as we go along. Cover the work with X's. Slash and burn! Bombs away! Our pages ought to look like Dresden."

I never fail to say "we" to my students because I do not want them to get the idea that you ever learn how to write, no matter how long you've done it. You need to remind yourself continually that every word counts, and to take Twain's dictum to heart—that the difference between the word and the right word is the difference between the lightning bug and the lightning. "We are in the lightning business," I tell them. "You need to remind yourself what not to do, as well, and to recognize when you've done something effectively the first time, so as not to say it again, poorly." I tell them the right word is often the unmodified word, and that the adornment of adjectives may suffocate the body under the clothes. Most nouns contain their own modifiers,

what Emerson called "the speaking language of things," and they will not be improved by a writer who wants to show off by making them any taller, fatter, happier, or prettier than they are. I tell them never to hold back, not to husband information and be coy. "Spill the beans. It's the only way to get more beans." I tell them not to stretch to find a different word for the sake of difference. "Read Hemingway's short stories, where he uses the same words over and over, and the words gain meaning with every repetition. If you have someone say something, let him 'say' it—not aver it, declare it, or intone it. Let the power reside in *what* he says." I will elaborate upon these and other matters in future classes, when their work illustrates a particular problem. For this first meeting, I just want to plant ideas in their heads.

"Work toward anticipation in your writing, not surprise. We stare at a stretch of land over which the sun is expected to rise, and we see the moon rise instead. Big deal. So what? But we stare and wait for the sun to rise, and it *does* rise. My, my!" I tell them to favor imagination over invention. Invention is easy. "A three-eared camel who speaks French and studies international diplomacy is one thing. But a real camel—humped and diva-eyed—is really strange." I tell them to value form, which often rescues content. "Wall-E, the little robot of the animated movie, discovers a box with a ring inside, and he throws away the ring, because the box is more

worthwhile." Richard Wilbur said that the power of the genie comes from its living in a bottle.

"Write your pieces as you would write your lives—with restraint, precision, generosity toward every point of view including the wicked ones, and in the service of significant subject matter."

"Yeah, right," says Diana.

MFA programs are supposed to be professional schools, akin to business, law, or medical school, but they are really schools for amateurs. With everything you write, it's as though you have never written a word before. Edgar Doctorow, who sometimes teaches in our program, describes his novel-writing process as driving at night and seeing only as far ahead as the headlights illuminate. This feeling of perpetual newness and disclosure keeps you from "learning" a craft in the commonly used sense, but it offers at least as many thrills as anxieties.

For the teacher, the process of recurrent learning staves off adamancy. You don't want even your most cherished ideas about writing to puddle and harden into orthodoxy. Every rule of good writing I can come up with presents exceptions that may or may not prove the rule. As a writer, I would never lock myself into set patterns. It would be foolish and misleading, not to say boring, to do so as a teacher.

"How do you tell the lightning bug from the lightning?" asks Ana.

"If you're going to write, you must think about words more seriously than you ever have. Learn to pick your spots, to choose when to use ordinary language and special, heightened language. But every word must be the only one for its place, and it must function in every way, not just adequately." Blank faces. "Okay. Here's a quotation from a T. S. Eliot poem, 'Sweeney Erect.'" I go to the board and write:

> Sweeney addressed full length to shave,
> Broadbottomed, pink from nape to base,
> Knows the female temperament . . .

When I get to the last line of the quatrain, I write, "And wipes the _____ around his face."

"What's going on in these lines?" They talk about a man shaving in preparation for an evening out. "What picture do you get of this man?" They conclude that he is lecherous, animalistic, full of himself. "Does he drink?" They think so. "Champagne or beer?" They think beer. "Anything else about him?" Some suggest that Sweeney is a wild man, uncontrolled, a big ape. "So he's comic?" Yes, they say, but darkly comic. "Is he mad?" They think, possibly.

I take my seat again. "With this picture in mind, what word is missing in the last line? It has to be a word that makes sense in terms of what Sweeney is doing, and that satisfies the impression you've taken of him—

lecherous, comic, beer-drinking, out of control, possibly mad."

They consider for a moment. "Cream," says Donna.

"Good. 'Cream' connotes lechery, and it fits with shaving. But that's all it gives us."

"Foam!" says Suzanne.

"Better. 'Foam' gives us madness and beer. But not the dark comedian." They kick around several possibilities. "The right word, the lightning in this instance, has to pack everything in. Yet, as you've figured out, it has to be simple, and one-syllable."

"Suds!" says Nina.

I clap and give her the thumbs-up. "And why did Eliot use 'suds'? Because of the lechery, the comedy, the potential madness, and the beer."

"That's the lightning," says Ana.

"Ain't it?"

"Any reason you're beginning with the short story?" asks George.

"Stories are central to life. They're everywhere: in the law, where a prosecutor tells one story and the defense tells another, and the jury decides which it prefers. The only reason O. J. Simpson got off in his murder trial was that the jury preferred Johnnie Cochran's story to Marcia Clark's. In medicine, a patient tells a doctor the story of his ailment, how he felt on this day or that, and the doctor tells the patient the story of the therapy, how he will feel this day and that, until, one hopes, the story

will have a happy ending. Politics? He who tells the best story wins, be it Pol Pot or FDR. The myths of businesses. The foundations of religions—the 'greatest story ever told.' Everything you write here is a story. Short stories tell stories, of course, yet so do essays and poems. An essay is the story of an idea or of a true event; a poem the story of a feeling.

"We start with the story because it is basic to human nature. It's like a biological fact, an inborn insistence. In the last days of the Warsaw ghetto, the Jews knew what was going to happen to them. They had seen their mothers and neighbors hauled off to the extermination camps, and were themselves dying of diphtheria and hunger. And yet they had the strength and the will to take scraps of paper on which they wrote poems, fragments of autobiography, political tracts, journal entries. And they rolled those scraps into small scrolls and slipped the scrolls into the crevices of the ghetto walls. Why? Why did they bother? With no news of the outer world available to them, they assumed the subhumans of the so-called Master Race had inherited the earth. If their scraps of paper were discovered, the victors would laugh at them, read and laugh, and tear them up. So why expose their writing, their souls, to derision? Because they had to do it. They had a story to tell. They had to tell a story."

I tell them about Jean-Dominique Bauby, the French editor of *Elle* who suffered so massive a stroke

that the only part of his body he could move was his left eyelid. Yet with that eyelid, he signaled the alphabet. And with that alphabet, he wrote an autobiography, *The Diving Bell and the Butterfly*. And about the skipper of the mackerel schooner in *The Perfect Storm*, who wrote a message by lantern light as his ship was going down. And about the messenger in the Book of Job, who had a story to tell. And about Melville's Ishmael, who alone was left to tell the tale.

"We like to distinguish ourselves from other animals by saying we're a rational species. That is sort of a commonly shared joke. But a narrative species? That, one can prove."

They are beginning to wonder why I am spending so much time on this subject. "And yet, if stories lie at the center of experience, indispensable to our being, there still must be those people responsible for telling them, those self-elected few who are the chief storytellers, and keep the race alive and kicking. And do you know who those people are?"

They stare at me, surprised. Someone asks, "Us?"

Throat-Clearing

"George? You gonna stay on the wagon this term?" A blizzard has arrived with February. The classroom windows are frosted, the glass so cold it looks as if it is about to crack and shatter. We all are in boots and heavy sweaters. George has snow dust on his sleeve.

He smiles. "Yessir." Suzanne smirks. They both know the "wagon" refers to clean, clear writing. George is cursed with an enormous vocabulary, a wealth of arcane knowledge and wit, some of it gained from his part-time work as a limousine chauffeur to rich and dangerous

people. He will make a very good book of this experience someday, but only if he tempers his verbal excesses and keeps his style intelligible.

"No binges, George." He nods.

His problem is a bit unusual, but it falls within a wider, more general category of student mistakes. Most of my students suffer bouts of throat-clearing—overwriting and hesitating at the beginning of a piece, instead of plunging in. The mistake derives from their not knowing what they mean to say. "What is this about?" I ask them over and over. "If you can't say what your piece is about, start from scratch. Find someone you trust to ask that question of you when I can't badger you. A friend, a spouse, a lover, a partner, anyone who will be hard on you. What is this *about*? You'll be happily surprised to find that most of your cloggings and chokings will vanish if you know what you mean to say."

"How do you know what something is about?" asks Nina. "When I'm in the middle of writing something, I often have no idea what it's about."

"Then wait till the end. If your piece is complete, it will be about something, and it is never about what happens in it, never about its plot."

I tell them about Russell Banks's *The Sweet Hereafter*. On the surface the novel is about the driver of a school bus in upstate New York who, on a wintry day, avoids hitting a dog on the road. At least, she thinks she saw a dog. She swerves right and jams on the brakes. The

bus rolls downhill into an icy pond. Fourteen children are killed. A lawyer comes to town. Lawsuits are prepared. The people of the town are suffused with anger and sorrow. So much for plot. But that is not what *The Sweet Hereafter* is about. It is about the need to assign blame, the urge to make explicable that which never can be explained. I have no idea whether Russell knew his theme from the start. But once he had discovered it, everything else in the novel worked in its service. All details accrued to it. All side roads returned to it.

"What is this about? What is this about?" Students will write paragraph after paragraph before that question occurs to them. So eager are they to impress the reader that they are, in fact, writers, they will often tie themselves in knots in order to sound learned or clever or, worst of all, beautiful.

About ten years ago, I hit upon a simple exercise that cures throat-clearing like a charm, at least for the moment of the exercise. I bring something to class that stimulates one of the senses—a rock to touch, a jazz recording to listen to, a teakettle or a similarly evocative object to look at. I ask the students to touch, listen, or see. "Sit quietly for a few minutes, and allow a thought or a memory to come to you." Once I brought phlox to class, gave each of the students a flower, told them to take in the scent and then follow their noses toward something to write. Many wrote of weddings and funerals they'd attended. One young woman wrote about

receiving her first corsage—the awkward boy pinning it to her lavender dress, and to her. Another young woman, whose arms were hidden by tattoos, recalled a job she had selling roses at the side of a highway. "Men stopped their cars to pick up a bunch or two," she wrote. "No one bought roses for me."

When I taught a writing course in the personal essay at Harvard's Kennedy School, in 2005, the class was full of bright, ambitious world-beaters who thought and wrote in orderly ways. But they had no idea how to reach what was individual to themselves as writers. Their writing lay flat on the page, unmoving. One day I walked into class, closed the door, and asked, "What did you just hear?" Someone said, "A closing door." I said, "Good. Listen again." And again, I opened and closed the door. I did it two or three more times, watching them listen. "Now," I said, "write whatever comes to mind as a result of hearing the door close." A gay man from South Africa, whose partner had walked out on him, focused on the sound of the lock as the door of their apartment closed. "He said we didn't click," he wrote. "But the door clicked." A young man from Chicago, the class clown, wrote about the Sunday morning his father walked out on his family. After the door closed, he and his mother, brothers, and sisters all sat down to eat pancakes. "Blueberry," he wrote. "They were blueberry." A woman in her forties, a marine scientist who lived on Cape Cod, who had written nothing lively or interesting in the class up

to that point, wrote of growing up in trailers on navy bases. She began her essay, "In my father's house there were no doors." I have a new throat-clearing idea to try out today, but I'll hold it till the end of class.

"Let's look at a writer who knew exactly how to plunge into a story."

I hand out copies of James Joyce's story "Clay," from *Dubliners.* I do this often—give students the best examples of what they're doing themselves, not to offer models, but to remind them that good readers make good writers. Our program requires students to take literature courses along with courses in writing. I ask them to look at the first sentence of "Clay," about the main character, Maria. "Practically all you need to know about Maria and her story is in that first sentence. How much information, pure information, does Joyce give us? Count the facts."

They study the sentence: "The matron had given her leave to go out as soon as the women's tea was over and Maria looked forward to her evening out." They come up with eight discrete items of information regarding Maria's station in life, where she works, what she does, what she's about to do, and hints of who she is.

"What about the name?"

"She has no last name," says Nina.

"And what does that tell you—the thing that isn't there?"

Nina says, "That she has no family."

"And what does that mean?"

"That she is alone," says Veronique.

"And if she's alone, without a family, without even a family name, what does *that* mean?"

"That Maria is unimportant," says Kristie.

"Yes yes yes. And since we know that Joyce would not write a story about someone unimportant unless she was important, we know that this is going to be a story that shows us the Maria, perhaps all the Marias, whom people fail to see. And it's all in the first sentence. Be very careful with beginnings. Be compelling. Suggest urgency. Readers are impatient. You have to grab them by the lapels right away, like the Ancient Mariner with the wedding guest, and tell them that nothing in their lives matters as much as listening to your story. See Joyce's little trick here. He's saying, if Maria is looking forward to her evening out, you should, too. It's going to be quite an evening. And it is."

I consider depressing them with the announcement that Joyce wrote this perfect story when he was eighteen years old. But I forbear. I remember my own depression when some cruel teacher told me.

When I dive into an idea like this one, it always feels new to me, though over the years I have said the same things about "Clay" to my classes a couple of hundred times. I lose myself in the story, no matter how familiar it is. I worry about it all over again, and the students overhear me worry about it. In this I am unconsciously

imitating teachers I admired when I was a student. John Kelleher, professor of Irish studies at Harvard, worried anew about Joyce every year, as did Douglas Bush, the great Renaissance scholar, about Milton. Teaching takes a lot of wheedling and grappling, but basically it is the art of seduction. Observing a teacher who is lost in the mystery of the material can be oddly seductive.

A recollection comes to mind, of teaching "Clay" to undergraduates many years ago. In the class was a young woman from one of the Caribbean islands, who was shy and spoke with a musical lilt. The world in which she grew up and that of late-nineteenth-century Irish James Joyce seemingly could not have been farther apart. And as far as I could tell from her classwork, she had very little practice analyzing a work of literature. But she raised her hand. "This line on page one," she said. "About Maria slicing the barmbrack bread so finely and evenly that one could not see the places where the knife had cut—isn't that what Joyce does in creating the character of Maria? You can't see the cuts?"

So often had I taught "Clay" that under hypnosis I could probably recite it from memory. But never had I heard anyone say what that young woman said. "Do you know," I told her, "you've probably noticed something about this story that's not only right, but has never been noticed before?" She smiled. The class smiled. I smiled.

"Some of you will teach as well as write. Moments like that one are why you'll do it."

Sven asks, "If beginnings of stories are supposed to grab you, are they like journalism?"

I grimace. Those who know me also know that I hate the intrusion of journalism when we're talking about real writing. But, "Yes," I answer. "Newspaper stories and fiction are alike in that—seeking your attention immediately. So are plays, especially one-acters. Something about the characters or the setting has to attract you right away."

"And poems too," says Suzanne.

"Absolutely. Whether the poem is the long form—'Of Man's First Disobedience, and the Fruit of That Forbidden Tree . . .' or 'Go and catch a falling star.' Who wrote that line, Jasmine? I forget." She will not deign to answer.

Funny about beginnings. They seem arbitrary—pick any point at which to begin—yet they often contain everything in the piece, in truncated form. This is true of other arts, as well. Of music. The overture to *The Magic Flute*, complicated as it is, compresses every element of the entire opera. Of course, the artist may create this compression only after he has finished the work, realized what it's about, and then made an adjustment back at the beginning. I suspect Fitzgerald did that with *Gatsby*. I think he figured out Jay Gatsby as he went along, then rewrote the beginning, when Nick warns us against easy judgments, to make everything fit. But just as often, we sense that somehow the writer knows where he or she

is going, even if the full meaning of the story has not yet revealed itself. And the beginning contains all that, hidden in code, like a cipher. In *Their Eyes Were Watching God* I'm pretty sure Zora Neale Hurston knew what she was doing from the start. Her beginning—about the different ways men and women see reality—claims her theme.

"Do you want us to read more than the first sentence of 'Clay'?" asks Diana.

I ignore the chuckles. "Good idea. Read all of 'Clay' for next week. And get ahold of Salinger's 'A Perfect Day for Bananafish' and 'The Laughing Man.' We'll talk about them, too. But for the moment, let's stay with beginnings. What *is* a beginning?"

"A very good way to start," said Kristie.

"That it is. But there are lots of good ways to start. Think of your story as a house with a thousand doors. You may enter your house from any one of its doors, but only one door is right for your story. How do you know?"

"Does it have to do with who tells the story?" asks Donna.

"You tell me."

"Well," she says, "I suppose that's what's meant by point of view."

"And why choose one point of view over another?"

"Because," says Jasmine, "that determines what you want your story to mean."

"Good. When Hamlet tells *Hamlet*, it means one

thing. When Rosencrantz and Guildenstern tell the play, it means something else. Same thing happens when the witch tells *Wicked*."

"Beginnings are impossible for me," says Kristie. "Even when you know who is to tell your story, it's hard to know where to begin."

"Where to begin?" says Nina. "People say that when they're scrounging around for a starting point."

"And they do that, because a starting point, of anything, is subjective. At best, it's the place where you think the story will unfold most completely and with greatest impact."

I poke about in my canvas book bag, and come up with a quotation from *Daniel Deronda*. It is one of a dozen such quotations I carry around, like a homeless man's furnishings.

"Men can do nothing without the make-believe of a beginning," wrote George Eliot. "Even Science, the strict measurer, is obliged to start with a make-believe unit, and must fix on a point in the stars' unceasing journey when his sidereal clock shall pretend that time is at Naught. . . . No retrospect will take us to the true beginning and whether our prologue be in heaven or on earth, it is but a fraction of that all-presupposing fact with which our story sets out."

"What is especially wonderful about Eliot's observation is what she says about the scientist, supposedly the least poetic of writers. Even he must guess at the

moment between the tick and the tock when time is nothing and the story of the universe can get under way. The beginning of a piece will often arrive on its own, unbidden. It will tilt at you, like a plant in the wind."

I forage for another quotation, from Kafka: "You do not need to leave your room. Remain sitting at your table and listen. Do not even listen, simply wait. Do not even wait, be quite still and solitary. The world will freely offer itself to you to be unmasked, it has no choice, it will roll in ecstasy at your feet."

"This is starting to sound mystical," says Sven, to whom the mystical does not seem to appeal.

"I know. Because often the beginning must just come to you. And I can't explain it, but it does."

We speak of the odd selectivity of the writer, and how it is tied to the imagination. Why do some things catch your eye, and some things don't? You notice a fragment of red wool caught on a hedge. Did the fragment merely drift there, or did it snag on the hedge, part of a sweater belonging to a girl who was walking by? Or was she making love with her boyfriend, the gardener's son? Or was she raped by a gang of bikers who held her against that hedge, and the red fabric was left to tell of the crime? Or did the piece of wool drop from the sky after an airplane explosion? Whatever its story, the redness stands out against the green hedge, which is natural and permanent, in splendid desolation. The remnant is human, temporary. It may blow away, but not yet, not before you notice it.

"You may be affected by your mood, too. Sometimes you're receptive to your imagination, sometimes you shut it out. Your phone rings. When you answer, the person on the other end hangs up. If you are not feeling writerly, you dismiss the incident as a wrong number. If you are feeling writerly, the person at the other end of the phone was your high school sweetheart who has longed for the sound of your voice all these years, or a burglar waiting for you to leave the house, or your friend who has a bone to pick with you, but thinks the better of it."

"Or a telemarketer," says Donna, "who just can't bring herself to do her job anymore, and whose conscience doesn't allow her to bother one more person—"

"And she runs from her office in the bank—," says Inur.

"In India," says Robert.

"And flees to Long Island," says Jasmine, "where she marries—"

"George!" says Suzanne. Her husband buries his head in his hands.

"Even the greatest of our writers can get off to a false start." I tell them about a public conversation with Edgar Doctorow at the Chautauqua Institution in upstate New York. Edgar told the audience he had written 150 pages of *The Book of Daniel* before he'd realized he had chosen the wrong way to tell the story. He'd written it in the third person, the so-called omniscient point of view. But *The Book of Daniel* is about innocence and its apprehen-

sion of injustice. It required the innocent voice, Daniel's. So one morning Edgar tossed out the 150 pages and started all over, letting the boy Daniel tell the story. I also wanted the class to understand that Edgar was happy to start from scratch, because he had picked the wrong door the first time.

"And how did he know which door was the right door? Because he remembered—"

"What the story was about," drone three or four.

"Did he really throw out all those pages?" asks Robert. The class looks dismayed.

"You think that's hard to do? You'd be surprised. When you know something doesn't work, and you chuck it, the feeling is pure liberation, nearly as good as doing something right in the first place. Actually, the feeling is better because the elimination of the wrong choice fortifies the rightness of the right one. Never wed yourself to a piece till it's finished and you're satisfied that all the parts work together. Often the section you prize the most, the one you've fallen head-over-heels in love with, turns out to be expendable. Toss it. What you thought was married bliss was really a one-night stand. You'll be deliriously happy to discover how thrilling it feels to get rid of something that does not fit your story—just like life."

"Can you hedge your bets," Diana asks, "and file away the thrown-out parts for use in another piece of work?"

"Writers do that all the time. But I tell you, in my experience, we're just fooling ourselves. Whenever I try to wedge my discarded beauty into another piece, the transplant fails. The unworkable withers in the desk drawer. We're always better off starting fresh."

"I'm amazed to learn that E. L. Doctorow ever had to clear his throat," says George.

"Happens to the best of us. And once you do it, you'll be surprised how fast you move. Good writers always know when something is wrong with a piece. They may kid themselves for a while, but the mistake eats at them until they have no choice but to act. They may not know what exactly is wrong, but it bothers them to death. It rattles the dishes at night, and bangs the shutters. And when they finally correct it, when they write that perfectly clear, just right sentence, they're off. They hurtle down the slope."

"Should we use an outline?" says Donna.

"Never. The trouble with using an outline is that you'll follow it." They titter. "I'm not joking. You'll cover everything you've put down in one portion of your outline, all the while aiming for what you've put in the following portion. All you'll be doing is reading a road map. You'll never surprise yourself with a sudden turn."

"I'm confused," says Diana. "Are we on a road or a ski slope?"

"When class is over, Diana, remind me to kill you."

"But won't an outline keep you orderly, so that you're clear to the reader?" asks Jasmine.

"Don't worry about the reader. Worry about the story. Your story will determine its own orderliness without your planning it out step by step."

"I have trouble figuring out what jobs to give my characters," says Nina.

"Because it's the last thing we think of. When creating a character, we usually start with the soul and then work outward from there. But it's a lot smarter to start with what the guy does for a living. There's a reason McTeague was a dentist. In Ann Petry's *Country Place*, the town stud runs the filling station."

"You said that we know what has happened in a short story before it begins," says Ana. "Then how do we know where to begin our story?"

"It grows out of the understanding of your characters you've already developed. You begin your story knowing everything about your people except what is going to happen to them."

When they read "A Perfect Day for Bananafish," they will see that it begins one afternoon, when something is about to happen to the despairing Seymour Glass. But they will also see that this beginning comes at a moment of impasse. It is the beginning of an inevitable end. After reading a novel, we often wonder what happens to the characters after the final page. We can imagine Pip's future, or Mrs. Verlock's, or Count Vronsky's. That rarely happens with short stories. In a way, they begin with an announcement of the end. After the last

page of a short story, there is no more Seymour Glass, and no more Maria either.

"So in effect you begin a short story by saying, 'We've come to this,'" says Ana.

"I wish I had said that."

"You will," says Kristie.

"I have a very hard time figuring out what to write," says Jasmine.

"Some days I simply cannot write," says Inur. "I can spend *weeks* clearing my throat."

"You ought to write every day if you can, even if it's a single sentence. But you can't force it. And you can't force subject matter. On the other hand, you can be proactive and find ways to allow your mind to be receptive to whatever may come its way." I tell them about Friedrich Schiller, who used to fill a dresser drawer with rotten apples, and begin his writing day by breathing in the fumes.

"*Mrs.* Schiller must have loved that," says Suzanne.

"The trick for a lot of writers is to create a state of mind where you are not thinking about writing. Rather create a state of reverie, a dream state. Dreams are where other people escape from reality. But for the writer, dreams *are* reality."

"What do you do to achieve that dream state?" Sven asks.

"Take a walk. That's what Dante and Nietzsche

did—they wrote on long walks. Wallace Stevens, on the other hand, dictated his poems to his secretary at the Hartford Insurance Company, where he worked."

"Do *you* use any rituals," Kristie asks me, "when you prepare to write?"

"Nothing elaborate. I start the morning with coffee, toast, and orange juice. Then usually, a bowl of Special K, with slices of banana or not. Finally, a shot of heroin, and I'm off."

"What if we're out of heroin?" asks Diana.

"Paddle about in a kayak. Ride a bike. Create a situation in which you look outside yourself. Something inside yourself will come to you."

"I find that's true," says Robert. "But the something that comes to me is freakish."

I agree with him. "But you may find that what started out as freakish eventually shows itself to be part of something universal. That often comes later in the piece, after you've started writing." It all comes down to that difference between invention and imagination. John Irving is a master of invention, but very little in his work displays a larger imagination. Imagination ties the freakish, as Robert calls it, to the eternal. "As writers you have to remind yourself that people are always strange. They don't need to have three nipples, or four ears, or be able to swallow the ocean in one gulp to be strange. And the great moment in writing something is

when you realize that the wonderful, unheard-of event you just made up is part of the wonderful, heard-of event of life itself."

"So what's the purpose of writing?" Donna asks. "To discover what is permanently beautiful?"

"Sometimes. Sometimes writing shows us what is beautiful, sometimes what is evil, sometimes what is ugly or petty or stupid. Writing is at heart a criticism of life, as Matthew Arnold said. And you can only criticize life effectively by using something recognizably within life, not something so way-out that it flies off the earth and never returns."

Suzanne looks skeptical. "Do you really believe in that mysterious receptive state you referred to?" she asks. "Most of the fiction I've read comes off as perfectly planned and worked out."

"Does it not? Not only that, it charts the sequence of things, how the events follow logically. So it all seems very neat. But it isn't neat. The orderly, sequential story you read probably came out of an initially mysterious moment, and a trance. And to your point, Suzanne, the final product probably wound up looking nothing like what the author originally envisioned. Some writers talk about their fiction getting away from them—how their characters take on lives of their own and go their own ways, as if rebelling against the author. That actually happens in Flann O'Brien's *At Swim-Two-Birds*.

It sounds wild, even nightmarish, but all the rebellion of characters really means is that a writer's vision changes as he gets deeper into the work. One of the things you'll find about this odd pursuit of ours is that you begin to trust change. Writing keeps you liberal. It shakes up your ideas about everything. Half the fiction we love, maybe more, looks nothing like the pictures their authors started out with."

"So that original, mystical inspiration is misleading?" Robert asks.

"No, Robert. It actually shows itself to be more mysterious than you thought. What you understand of it at the outset is simply different from what you understand of it in the end."

The windows frame a light snowfall. I look at it a moment, pause for effect, then burst into song: "Happy Birthday to You." They give me the he's-gone-nuts look I've come to cherish over the years. I sing it again. "Happy Birthday to You. Anyone had a birthday recently? Anyone *about* to have one?" Two or three raise their hands. I choose Sven. "Let's all sing 'Happy Birthday' to Sven." He looks less pleased than confused.

"Now here's what I'd like you to do for your short story. Hear the song 'Happy Birthday' in your minds, and start to write. Don't worry if, when you're alone, the story doesn't pan out. For the present, just sit back and see what comes of listening to this irritating, cele-

bratory song you've heard all your lives." I sing it again. "Now write."

I watch them lean back for a minute or two, then lean forward, and go at it. The classroom is still, save for the motion of their hands on paper. This is how we begin.

Three

My Story, My Self

That year I taught at the Kennedy School yielded the most unusual student I ever taught, the hardest nut to crack, and, in the end, one of the most rewarding. Anurada came to the essay-writing class after a tour in the Marines in Iraq, where she served as the lone woman in a hand-to-hand combat unit. She stood about five-four, and weighed no more than 110 pounds. And except for the standard-issue student outfit of a T-shirt and jeans, she looked quite feminine, with a touch of the tomboy. When she was seeking a subject

for her essay, naturally I urged her to write about her Marines experience, but she refused. I asked again. She continued to say no. "Play to your strength, Anu. You have a unique story." She said no. "You're squandering once-in-a-lifetime material." She said no. This fruitless exchange went on deep into the semester, until it occurred to me that I should treat her the way her other recent superiors had treated her, and simply give her an order to write the essay. I became her CO. She came through with a stunning piece that was framed by her antiwar work after her tour of duty.

Know thyself. The Greeks didn't restrict that piece of advice to writers, but writers cannot do without it. In embracing what she had most strongly resisted, Anurada did not merely find her subject in her life in the Marines, she found who she was. That is what I want for all my students. Eventually, they will discover that their writing validates their lives. Somewhere in Inur's exotic family history is an authentic self with an authentic story and an authentic way of telling it. The same is true for Ana's rarefied upbringing, and for Veronique's work photographing street crimes, and for Jasmine, who "has never experienced anything," and for Donna, Kristie, and Robert, who have spent most of their lives on Long Island, and for Diana on her parallel bars, Nina in her library, Suzanne and her Quonset huts, George in his limousine, and Sven in his warplanes. The stories they discover in themselves will not depend on their

adventures or the lack of them, but on more hidden things, like the fear of loud noises and their capacities for viciousness and betrayal and yearnings for nobility and feelings about justice—all the generally human things that define us. They may not make their self-discoveries during the time they work with me, but it is my business to spot the revelatory moments in their writing, and to pause and say "Here you are." When I find something essential in their work, I am helping them get a glimpse of themselves. And when they learn to spot these things on their own, they will string the moments together sentence after sentence, and will begin to feel the shaky exhilaration of being a writer.

In the fourth week of classes we turn to their stories with such questions as the nature of beginnings hanging in the air. I tend to conduct my courses like a juggler with a dozen dinner plates spinning on sticks at once. When one plate wobbles and threatens to fall, spin it some more. Keep them all going. No topic in writing is independent of any other, and nothing is ever done with.

"Let's look at Diana's 'A Candle in the Forest.' " Diana used "Happy Birthday" to make a story about an ill-matched couple. It begins with the narrator over-hearing his girlfriend Elizabeth being serenaded on her birthday by friends. The narrator is imprisoned upstairs with a broken foot. He'd broken it running downstairs, in an effort to escape the house and his girlfriend, Elizabeth:

Maybe I had no reason to leave, though I told
her I was running down the stairs because I'd
left my headlights on. Lizzy has expectations for
me and I shouldn't feel overwhelmed. She thinks
I should get my master's and teach college,
says my talents exceed typing up the Sunday
real estate section of the *North Country Post-
Standard*. She thinks I should learn to cook more
than spaghetti noodles and frozen vegetables.
She says that my scruff makes me look home-
less and hates that my hair is longer than hers.
"What are you, a rock star?" she scoffs. I like my
hair. But maybe she's onto something. Maybe I
should be teaching myself French and reading
Proust like she does every night after dinner.

"Do you like that paragraph?" They nod and smile.
I ask them why.

"Diana gets so much into it," says Veronique. "The
status of the narrator. His boring job. How he thinks
about Elizabeth. How she thinks about him. Her high-
falutin' education. His humor. Even his appearance. It's
all in one paragraph."

"What is a paragraph, anyway?" asks Suzanne.

"Damned if I know. I used to think I knew what
a paragraph was until a few months ago, when I did a
piece for the *New Yorker*. My editor, Dorothy Wicken-
den, changed my entire view of a paragraph simply by

editing the piece a certain way. I wrote three paragraphs, and Dorothy would yoke them into one. And it read much better."

"But a paragraph is just one idea, one complete movement," Ana says. "You write one movement. Then you go on to the next."

"So I thought. But Dorothy showed me a wholly new way to look at a paragraph, which also turns out to be a more modest way to write. When you write a paragraph as a complete idea, as Ana suggests, or as a complete feeling, and then you stop, it's as if you are saying to the reader, 'See? Aren't I smart? Don't I look pretty?' But if you compile a bunch of thoughts, as Diana did here, you draw less attention to the writing. You pile on the information, half burying the gems you've come up with. At my decrepit age, I finally may be learning how to write a paragraph."

Ordinarily I do not refer to something I've written, as I did with the *New Yorker* piece, unless it fits the discussion and is of immediate use to the students. The effect is to call attention to the fact that they are being taught by a professional. But that is not entirely bad. They like it, and I make use of it, though I try not to abuse the privilege. Writers who teach get away with things other teachers do not. We are placed on pedestals that we often erect ourselves. Professors of subjects with longer histories and thick syllabi do much more work. They drill the pilings. We paint the frescoes. Yet

it is us the students adore. When they read about writers in books, we look heroic—disheveled, glamorous leaders of corrupt-yet-desirable lives. Michael Chabon's *Wonder Boys* presents a perfect picture of the writing teacher in Professor Tripp, whose very name bespeaks the drugged-out, irresponsible, adventurous existence. His wife leaves him, he knocks up the provost, and he is finally fired by the department chair, who happens to be the provost's husband. But there is not a student at his university, or anyone who reads about him, who would not trade places in a trice.

Still, you have to be careful playing the dual roles of teacher and writer. As a teacher, you may not bear the features of the bloodless Ichabod Crane or the buffoonish professor of *The Blue Angel*, but you're sort of a fictional character yourself. Writing teachers who think of themselves as writers who dabble in teaching implicitly condemn the work they're engaged in. The old saw that writing cannot be taught is a back-door put-down of the teacher. And the idea cheats the students.

Every teacher eventually finds the most comfortable method or manner of teaching, which is inevitably an extension of personality. At Harvard I took a poetry-writing seminar with Robert Lowell. Lowell's teaching method was a dry and distant severity. "This is not very good at all," he would say with that high-pitched, complaining, nearly whining southern patrician voice of his. "This is very weak"—of nearly all the

students' poems we brought before him, like tithes. Yet Lowell's method succeeded because it was consistent with who he was, coolly distraught and more than a little scary. He was also the greatest poet in America at the time, and when he liked a line or even a word in your poem, you knew you were getting the goods. Late in the term, when his bipolar condition was starting to veer toward its depressive state, he would become uncritical, and would say nice things about everything we wrote. That depressed *us*.

Not being of Lowell's temperament, and not being the greatest anything in America, I could not get away with teaching as Lowell taught even if I wanted to. I actually tried it one year, doing my level best to sound like John Houseman in *The Paper Chase*, without the English accent. I was absurd. The students learned nothing, except, perhaps, the art of ridicule. The method that suits me is praise laced with broad, and transparently good-natured, insults. The insults merely goad, but the praise is sincere and frequent, and it is more practically useful than it sounds. If you find things you like in a student's work, and you celebrate them, then the things you don't like— the really awful parts—will seem anomalous mistakes uncharacteristic of the writer, ones they can correct. The students will side with you against their own weaknesses. If, on the other hand, they begin to think they can't do anything right, they will get worse and worse. No matter how cheerfully they appear to take your criticism, or

how mature their attitude, they will think to themselves, "I can't do this." Or they'll write defensively, anticipating your familiar objections, and be dull within safety.

"George, will you look at this sentence of yours?" I read aloud from his short story called "They say it's your birthday"—" 'He was home, where all his roads ended and began.' "

"What's wrong with your sentence, George?" And before he comes up with something for the hell of it, I shout, "Nothing! This is a perfect sentence. Clear, undecorated, revealing, powerful. You are capable of perfection! Congratulations!

"Now compare it to your second paragraph:

No party favor or decoration brightened the
Spartan rooms. Every window had closed blinds,
atop drawn shades. Wherever a blue slit of
melting gelatin sky might slip through, antique
newsprint was carefully taped across it to block
the gaps of burning sunshine. Sheets were
draped over every wall monitor, every house
appliance eye was cloaked with a concealing
cowl or cozy. Two oil lamps with smudged glass
flues glimmered on the table. In each room, rafts
of tall, thick candles glowed dimly.

"Okay, George. You tell me what's wrong with this. We only have a week." We cover all the examples of

overwriting, which constitute most of the paragraph. "Here's why I'm pissed off at you, George. The substance of this passage is riveting. The windows, the blinds, the newsprint, the cozies on the appliances. Nouns, nouns, nouns. You've got all your nouns ready to do the work. Why am I pissed off, George?"

"Because I just should have simply said what's in the room," he says. "I do get it, you know. Sometimes I can't help myself." Suzanne pats his arm.

Some students' stories have used the happy birthday idea, some have not. Ana has written about a woman, recently divorced, who dreads a visit from her father, a gallant roué. He arrives with "his Latin dash intact." Inur's story tells of a woman, lonely in her marriage, who depends on store catalogs for her social life. Jasmine has written a strange, Edgar Allan Poe–like story of one man so obsessed with another, he takes over his life. Suzanne's story is about a strong Irish woman whose husband dies when she's pregnant with their son; Kristie's, about a woman ditched by her boyfriend and snowbound in Vermont. Veronique has written a tender story about a boy named Arthur whose father remarries after the death of his mother—Arthur's helpless loneliness. Sven has written a long, ambitious story about a couple of guys who wind up in a bar in Aberdeen and get told a story—a story within a story. It doesn't quite work because the outer story is more effective than the inner one. But Sven is a clean writer. I tell him to give more

thought to his subject, and then to start with what surprises him.

"Robert, would you give us your first paragraph?" He reads:

> I peer out my window as my mother pilots
> our station wagon effortlessly away from the
> monotony of expressway traffic through the
> graceful curves of the beautifully named Mead-
> owbrook and onto the freedom, mobility and
> relative exclusivity of the Northern State. It is
> summer, 1959, and we are mobile, and living
> Robert Moses' dream. The Chevrolet is huge
> and blue and packed with promise. My mother
> is at home, here on the parkway, filled with the
> confidence of her ability to drive, to navigate
> away from where she came. Poppy, who taught
> her this and so much more, says she drives like a
> cowboy, and she delights in confiding this to me,
> her tow-headed son.

"What do you think of this?" The class goes over some of the successful particulars in the passage—the mother "piloting" the station wagon, her "confidence," her ability to "navigate," her driving "like a cowboy." We note how much Robert gets into this first paragraph. The place. The time. The character of the mother and her relationship to her watchful, innocent son. Most of

all, the "promise" of the situation, and Robert Moses's dream, which was the dream of Middle American happiness won at the expense of minorities and the poor. All this Robert packs into a car ride, in a Chevrolet, on the Meadowbrook. We speak of how the feel of the entire story is encapsulated in its beginning, so when the piece eventually widens to include the whole family, it is as if we are being told of an entire world. We appreciate Robert's ability to draw character with a picture—"My father's pipe was a disgusting thing: a cracked, charred wooden bowl at the end of a smelly, denture-worn plastic stem." We feel the freedom Robert felt on Jones Beach as a boy. America, the whole of it, good and bad and self-deluding, breathes in his story.

Donna's story, a fable for adults, begins with "Happy Birthday to You" sung to Mr. Elephant by the mice in his employ. The mice work in a mousetrap factory. "They punched in Monday through Friday at 8:00 a.m., and were home by 4:00 in the afternoon." The class talks about how "punched in" signals that this is a fable for grown-ups. The piece involves mouse complaints about working conditions, a petition demanding more food for the workers, mouse rights as opposed to elephant power, and eventually the moral: Mice need to learn how to get their own food, and to think for themselves.

"What's the function of the Happy Birthday song at the outset?" I ask. "Do the mice really wish Mr. Elephant a Happy Birthday?"

"They want more food," says Ana. "They're sucking up."

"So the song of celebration is insincere," says Jasmine.

"That's what the story is about," says Robert. "The mice are trapped by their own subservience."

"Which means that working for the elephants has forced them to lose track of who they are," says Inur.

"Or to remember who they are at the core," says Nina. "Mice."

We talk about this being an interesting and complicated idea. "But is it the idea that Donna promotes?" I ask. "The moral of her fable pales in comparison to this question of the self-manufactured traps of the servile mind, does it not?" I check Donna's reaction to ascertain that she is attentive, not hurt. "Children's fables are not complicated because they're for children. Aesop's fable of the lion, the fox, the jackal, and the wolf is simply about hogging, to mix animal metaphors. By the way, people say 'the lion's share' to signify the larger portion, but in the fable the lion eats it all, everything. So the lion's share, used properly, means everything. Don't say you didn't learn anything in this course."

"Are you saying that a children's fable aimed at adults has to be more complicated?" asks Veronique.

"More complicated, more interesting, more important. Do you know James Thurber's animal fables?" They shake their heads. "Do you know James Thurber?"

A couple of students say they've heard the name, but that's about it.

"That's the trouble with humor writing. It rarely holds over from one generation to the next. A hundred years ago, people found Finley Peter Dunne's Mr. Dooley hilarious and sharp. The same was true of Langston Hughes's newspaper columns about Jesse B. Semple, the 'Simple' stories. Today, both characters are a yawn. Thurber was a wonderful writer, a major writer, but he's practically disappeared." I tell them about "The Owl Who Was God" and "The Wolves Who Ate All the Rabbits." "Thurber's fables were written about grown-up issues, and were put in children's language to emphasize the importance of the ideas. It's as if he was saying, Even a child can understand this. The owl fable is about the ease with which people are led by false prophets, and the wolves fable is about the Nazis. The wolves eat the rabbits, and then tell the world it's none of its business, because the rabbits had become 'an internal matter.' " I ask our author, "Donna, is your message of fending for oneself important enough to merit the use of the fable form?"

"It's important," she says. "But maybe you're right. It's a little easy." I love it when students open up to criticism, and this particular criticism of mine is the hardest to take, because it applies to the intelligence of the work. Only someone who really wants to write better will respond as Donna does, and I think that her back-

ground in business—dealing with problems that have to be solved—helps.

"A fable for grown-ups must be about something they did not realize and could not learn in any better way."

"But I like Donna's story," says Kristie. Many others nod in agreement.

"So do I. It's just not as smart as it could be. In a form like this, you need to be as smart as you can be. Your mice might surprise you by how smart they can become, Donna. Characters do surprise you. Eudora Welty said that in *One Writer's Beginnings*."

"Yes," says Inur. "But are those real surprises? Don't they have to be in you before you let them out?"

"The surprise is that they're in you. Amazing, preposterous things. Hemingway led a life of fights and blood sports. Welty led a sheltered life. Yet when it came to putting words on paper, Ernest was no wilder than Eudora."

We come to Nina's story, "A Taste of Plums," which uses "Happy Birthday" as a dirge. "They'd never found her out," it begins. "Not one of them had ever suspected what really happened, not even her father. She'd known they would not, for the simple reason that they'd all underestimated her; they'd failed to recognize the mind behind the protective disguise. And yet what had it been, that wonderful disguise of hers? It had been nothing more than a bodice and petticoat. Nothing more than that she was a girl."

Her story is about Shakespeare's daughter, Judith, whose twin brother Hamnet is favored by the family, especially by the father, solely because Hamnet is male. At the twins' birthday, it is Hamnet who is honored. Shakespeare ignores his daughter. So, carefully and deliberately, Judith plots to poison her brother using the very poison that her father was testing when he was writing *Romeo and Juliet*. Nina tells her story in a way that both pleases the class and raises a question. She gives it a surprise ending, concealing Shakespeare's identity till the last line and making it seem a tale of more ordinary people living in a time when women were ignored.

"Why are surprise endings hard to pull off?" I ask the class.

"Because the surprise has to be worth it," says Sven.

"Right you are. O. Henry, the king of the surprise-ending short story, only rarely succeeded—"The Gift of the Magi," maybe one or two others—because the surprise ending wasn't worth the trouble it took to reach it. Something was suddenly revealed, and you didn't care."

"But Nina's surprise is worth the wait," says Sven. Others agree.

"You bet it is, which is why the story is very good. But we have to ask ourselves, on Nina's behalf—would the story be better if we knew Shakespeare's identity from the start?"

I had mentioned the difference between anticipation and surprise before. Now, with a concrete example

before us, I try to show that anticipation is more satis-fying, because it allows a thought or a feeling to build in your mind, rather than assaulting you with a sudden twist. "Coleridge wrote about this when he was praising, of all people, Shakespeare. He said the power of *Hamlet* comes from the fact that we know Hamlet will die from the start, and when he does die finally, his death is much more moving."

"Funny about plays like *Hamlet*," says Nina, who has studied Shakespeare recently. Nina is one of the more well-read of the group, but she never shows off. "You know Hamlet will die every time you see the play, but somehow you hope he won't."

"So, Nina. What do you think? Would your story be better off spilling the beans at the outset?" She is mull-ing it over.

Most of Nina's story is told in the first person. "Why choose one voice over another? First person, sec-ond, third?" They all come up with the obvious answers involving the scope of purview and information avail-able to each of the voices. "But is there not some other advantage, particularly to the first-person voice that Nina uses?"

"Well," says Jasmine, "we know that the narrator will survive the story—unless she's already dead, like the narrator of *The Lovely Bones*. But logic dictates that the person telling us the story survives."

"And what does that fact suggest? Ishmael survives,

the woman in *Rebecca* survives, Pip survives, Nick Carraway survives. What do their stories have in common?"

After a moment: "They suggest that the people they are telling us about may not survive," says Robert.

"Nice. We have no proof of this, but every time we are greeted by a first-person narrator who announces a story about someone else—the narrator of *The Good Soldier*, for instance—we can be fairly sure that the person whom the story is about will meet a bad end."

"As in 'The Laughing Man,' " says Sven.

"As in 'The Laughing Man,' since we know at the outset of Salinger's story, merely by the way the boy tells the tale, that his hero's heart will be broken."

"Don't you take a risk, writing in the first person?" says Ana. "Either you glorify yourself or you humiliate yourself. Either way, the reader dislikes it."

"So you think every story should begin 'Once upon a time.' It's an interesting point of view. I'd adopt it if I, and you, hadn't read dozens of great stories told in the first person."

"I guess it's a matter of individual talent," says Ana. "The strength of an individual voice."

"What's all this talk of 'voice'?" asks Suzanne.

"You mean, 'all this crap,' don't you?"

"If you insist. Yes. Crap. That's all anyone talks about when they talk about writing. Voice. If, at my age, I don't know my own voice, I'll never know it."

I tell her she's right, that "voice" is merely the lat-

est cliché to signify good writing. Its predecessor was "authority." She is also right about linking self-knowledge to writing. "But instead of thinking of self-knowledge as idiosyncratic, try connecting it more to the task at hand. Subject matter determines voice. Voice should be selfless. Want to tell a tale in the voice of an idiot savant? Try *The Sound and the Fury*. Want to create an innocent learning morality? Put your glasses on Huckleberry Finn's nose, but make sure the reader sees more of Huck's nose than your glasses. Voice is the knowledge of what you want to say. After that, it becomes any voice that serves your purpose."

"I find I don't know what I mean to say till I start to write," says Robert.

"You find that you don't know what you *think* until you write it, too. You'll be going along writing sentence after sentence about some slight received by a character, then you find yourself growing angrier on his behalf. Before you realize it, you're in a rage, and the rage is what you felt from the start, though you had no sign of it until the words unearthed it. If we have to put it in terms of 'voice,' voice may be the imprisoned you, waiting to be paroled."

"We write what we are," says Nina.

"I think so. What we are, what we fear, what we love, what we believe, what we want the world to be."

"Do you believe that?" Sven asks me. "That we write to change the world?"

"I do. If we look like we're trying to change the world, the writing will sink from the weight of its own piety. But in the best of our work, the idealism is there, like trout below the surface of the water. Of course you want to try to change the world. You just don't want to show your cards. But look at the world. Who would not want to change it? Books count. They disturb people. You never heard of a tyrant who wanted to burn the TV sets."

I ask if they know who first wrote the line, "We are the world." Naturally, they say Michael Jackson. "Uh-uh. It was a poet. Robert Penn Warren," I tell them:

> We are the world, and it is too late
> to pretend we are children at dusk watching fireflies.
> We must frame, then, more firmly the idea of good.

"What if readers don't like the way you want to change the world?" asks George. "I know you don't want to stoop to such a practical subject, but if you hope to change the world, you ought to have a few people on your side."

"You're a goner if you write for any standards but your own. Some will love your work. Some will hate it. Either way, you must simply go at it. You know Bill Russell, the great Boston Celtics center? He was the best player of his day, but he was black playing basketball in antiblack Boston, and his slightest error was always crushed under

boos and catcalls. Russell's daughter asked him, 'Daddy, what do you think when they boo you like that?' He said, 'I never hear the boos because I never hear the cheers.' Your vision, only your vision, matters."

One of the pleasures of teaching writing courses is that you can encourage extravagant thoughts like this in your students. These are the thoughts that will be concealed in plain and modest sentences when they write. But before that artistic reduction occurs, you want your students to think big—to think big and write small. I don't tell them that in so many words. But there's no purpose to writing unless you believe in significant things—right over wrong, good over evil. Your writing may deal with the gray areas between the absolutes, and all the relativities that life requires. But you still need to acknowledge that the absolutes exist, and that you are on the side of the angels. I have never known a great writer who did not believe in decency and right action, however earnestly he or his characters strayed from it.

"Writing is the cure for the disease of living. Doing it may sometimes feel like an escape from the world, but at its best moments it is an act of rescue. Each of you has his own way of seeing into suffering and error. But you share the desire to save the world from its blights by going deeper into them until they lie exposed. You show up the imperfections of living for what they are. You hope to write them out of existence."

"Say that again?" says Diana. "Not the whole thing.

Just the part about writing being the cure for the disease of living."

"You like that?" I ask foolishly.

"Not especially," she says. "But you're the only person I know who would dare talk like that." More laughter at my expense.

"It seems that you're saying a writer should write with moderation, but think grandiosely?" Ana asks.

"That's it. Trust not the humble writer. Every one of us craves immortality. Every one of us harbors a special fear and hatred of dying, both for its finality and its solitude. A writer wants to continue to live among others, many others, and that may only be accomplished through his work. This is why all writers long to be loved by younger readers. The young will imitate them and re-create them over and over."

"We've spent a lot of time on the beginnings of stories," says Nina. "What about endings?"

"Much easier, I think. Because your ending lies within your beginning. You simply have to discover it again and follow it to its anticipated conclusion. Like Harold in *Harold and the Purple Crayon*, when he draws his window in order to get home, and creates what he knows or suspects already exists."

"The end was in the beginning," says Donna.

"Eventually, we all tell the same stories, yet none of our stories sounds like anyone else's. Think of your dullest family member, the pixilated uncle who tells the

same family anecdote over and over every Thanksgiving. Even he never tells his story the same way twice."

"I really don't think of my voice as special," says Suzanne.

"It may not be. But it's different from George's."

"I hope so," she says. He chuckles.

"But if we're all different," says Jasmine, "how will we write the way you want us to write?"

"Sameness has to do with commonly agreed-upon qualities. That's all."

"Are we all supposed to wind up writing like you?" asks Inur.

"That would be impossible." I remain deadpan.

"I mean it," she says. "If what you tell us constitutes good writing, it's the writing you believe in, the writing you do yourself."

"Well, you're right about one thing. I believe in spare writing. Precise and restrained writing. I like short sentences. Fragmented sentences, sometimes. I enjoy dropping in exotic words from time to time. Either they put off readers or drive them to the dictionary. I do it anyway. I've enjoyed reading florid writing and thunderous writing, and even manically self-conscious writing. But I don't want to do it myself. And I don't want you to do it."

"Is there never a time we should use heightened language?" Nina asks.

"There's a saying about the making of musicals: 'When you can't talk anymore, sing. When you can't

walk anymore, dance.' I think it works for writing too. You go along, telling your story, and it's moving very well and very fast, and then, like a glider pilot, you come to a cliff and you have no choice but to soar."

"Is this another one of these mystical things?" asks Sven. "Fly when you hit the cliff?"

"It gets less mystical the more you do it."

"How do you practice heightened language?" Donna asks.

"Concentrate on every word you write."

"We're back to that," says Suzanne. "The lightning."

"We're back to that. We never leave it. Every word is an idea. It triggers images in your reader's mind. Let's say you've created a woman in your story, and you want to describe her hair color, which is a mixture of browns."

"A *medley* of browns," says Ana.

"There you go. Every word you use to describe your woman's hair gives you something about the woman herself. Otherwise there's no point in heightening the language around her. So her hair can be the color of freshly tilled earth, or of old books on a shelf, or of a dirt road . . ."

"After a rain," says Jasmine.

"After a rain. Better. Or an old tweed coat, or bricks in a fireplace . . ."

"Or stones in an aqueduct," says Sven. "Or the stock of an antique rifle."

"Or a newly dug grave," says George.

"Which is not the same as freshly tilled earth," says Donna.

"Or the woods on a winter day," says Kristie. "Or a dish of oatmeal."

"Or mixed nuts."

"Her hair was a box of light and dark chocolates," says Suzanne.

"A *medley* of light and dark chocolates," says Ana.

"A medley of milk chocolate and dark," says Veronique.

"What if you said her hair was a Whitman's Sampler? What would you be saying about her?"

"Old-fashioned and delicious," says Kristie.

"And boring," says Diana.

Wordsworth quoted Coleridge as saying that every poet must create the taste by which he is relished. The same is true of teachers. I really don't want my students to write as I do, but I want them to think about writing as I do. In them I am consciously creating a certain taste for what I believe constitutes skillful and effective writing. I want them to be both clear and wild in their work. The hammer descends on the nail. The nail is driven deep into the wood. And the wood sings.

Memory and Dreams

Kristie comes to office hours to ask me to write rec-
ommendations for her. She is applying to Ph.D
programs in English. "Why, for God's sake?"

"So I can grow up to be just like you," she says.

She has landed an assistant teaching position at a
local community college, which, in the current market,
wasn't easy. "First thing I teach my students is about
throat-clearing," she says. Amazing, the influence of
teachers. I use a little phrase to make a point. Kristie tells
it to her students, one of whom may become a teacher of
writing, and tell others. "A ripple widening from a single

stone," wrote Theodore Roethke, "winding around the waters of the world." Or, as one of the James boys put it—William or Henry, I can't recall which—"a teacher can never tell where his influence stops."

The teaching of writing is like publishing something you write. You come up with an idea, and out it goes. Only with teaching you don't get first and second "passes," a publisher's term for proofs you can have second thoughts about and correct. You need to be as careful with what you say as a teacher as you are as a writer—maybe more careful, because as soon as you go public with your words, your students will blow them about like rumors. What I teach my students about writing may become writing. I try not to overthink this, because the burden of competence is daunting.

Like Kristie, I am but one teacher who has had a few memorable teachers. Yet I have spread their thoughts and inventions abroad like a town crier. And I have learned over the years that my students have taken those same thoughts and inventions and have done as I have done. For my Modern Poetry course, the students' assignment is to produce an anthology of poems. I put some forty recently published books of poems by contemporary poets on reserve in the university library. Throughout the term, along with our discussions in class of established modern poets—Elizabeth Bishop, W. H. Auden, Langston Hughes, William Empson, Margaret Atwood, Marianne Moore, Robert Lowell, Wallace Ste-

vens, Sylvia Plath, Robert Graves, and the like—I ask the students to read the forty new books, which we do not discuss in class, and select ten poems from different authors for their anthologies. Then I ask them to write a ten-page introduction explaining their choices. By the end of the course they have created a little book that speaks for their taste. It is a wonderful assignment, and not my own. I took it from John L. Sweeney, curator of the Woodbury Poetry Room at Harvard—a brilliant, courtly teacher who looked like the actor Edmund Gwen, and whose Modern Poetry class I lucked into when I was a first-year graduate student. Jack Sweeney and his wife Màire retired to County Clare in Ireland, and have long since died. But this idea of his lives—such a good way to develop independent discrimination in poetry.

Another thing Jack Sweeney did which I also try to imitate: he found something valuable in every comment students made, no matter how far off the mark it might be. I'm not as consistently good at this as Jack was, but I'm aware of its warming effect on a classroom. If you give every student the idea that his answer can never be entirely wrong, it makes him feel part of the group enterprise. We're all in the same leaky boat in a writing class. No one, the teacher included, is ever completely right anyway. Jack used to say: "Yes! Yes! Yes!" in response to a comment that might as well have claimed that black was white and up was down. "Right!" he'd say,

and then very slowly, like a weaver, proceed to spin gold out of poppycock.

After Kristie leaves, I look at my students' short stories one more time before the class moves on to essays. I do this for a couple of reasons. The first is simply to check if I was wrong about something the first time round. It happens. I can get so caught up in verbal errors, or in my own definition of what constitutes good writing, I sometimes fail to catch something new. I miss the larger picture. I'm not sure I would have recognized Donald Barthelme as the writer he was. Or Amy Hempel. I'm pretty sure I would have told Michael Chabon to calm down and limit his exhibitions of learning, so that the reader might feel something other than dazzle. Right or wrong as these judgments might have been, they would have been deadly to young writers who were trying to write with a difference. So I reread my students' work in which I have found this fault or that, to see if I was looking at too many trees, too close up.

Then, too, I like to descend on a piece of work like an octopus, tentacles stretching to clasp as many conclusions as possible. In a first reading I may see strains of mythology running through the text. In another reading I may see the story as a morality play. Or I may dwell on the logic of the piece, and read it as a science paper. It pleases me to change my mind this way—not to demonstrate my agility, but rather to show how many interpretations are available to a student's work of which

they remain gloriously unconscious. "You meant this ambiguity, did you not?" I'll ask Donna or Jasmine. And before they deny any such intent, I'll say, "Of course you meant it. Whenever anyone discovers something brilliant in your work, you meant it."

The main reason I reread their work has to do with the way they think of themselves. The other night, Helen Simonson, a graduate of our program, gave a reading from her novel *Major Pettigrew's Last Stand*, which has become a great critical and commercial success. Helen was my student many years ago, and because she had a family to tend to, it took her all those years to finish her book. Before proceeding to read, she told the audience that what she cherished most about our MFA writing program is that the teachers made her feel like a colleague while she was becoming one. In that, she offered the best reason for rereading the students' work. I simply want to show them that I think enough of them to dwell on what they write. All the teachers in our program do the same. Bob Reeves, who shapes and leads the program, has done many remarkable things, but none more useful than this—to encourage us to make the students feel alive and significant in a world that tells them they don't count. A student in a novella class I taught a while back said to me, with a sort of wonder, "How do you remember all our stories? You seem to recall every character, every detail." I may seem to, but after a semester is over, I rarely remember most of the things written for a particular class. For

the time I am teaching them, however, I want the students to feel that their work is the most important thing on earth. When a few of them become real writers, they will know the deep abiding pleasure of hearing a stranger quote a line of theirs. I like to give them a foretaste of that.

"How many novelists can you name?" I ask the group at our seventh meeting. It is endless March, the heart of the bleak season on eastern Long Island. Only the lights from the college buildings, blazing in the dark, suggest life. "How many novelists can you name?" Some of them are counting on their fingers.

"Twenty," says Inur.

"Oh, you can name many more than that. Don't you think you could name at least fifty?"

"I suppose," she says.

"A thousand," said Diana, full of mischief.

"Go ahead, Diana," says George. "And do it alphabetically."

"Aaron Aardvark," says Diana. "The great novelist of the Antilles."

"Abyssinia," Jasmine corrects her.

"While we're waiting for Diana's novelists beginning with B, how many essayists can you name?"

"You," says Kristie.

"That's one. The last shall be first. Name another essayist."

"Bacon," says Sven.

"That's two." A long silence follows.

"Emerson," says Suzanne.

"And his delightful walking companion, Thoreau," says Diana.

"So we're up to four, if you still count me, and I wouldn't. But I *would* count Montaigne. And Orwell. And G. K. Chesterson—you should read Chesterson's 'A Piece of Chalk.' James Baldwin wrote some remarkable essays. Mary McCarthy, too. And Annie Dillard. And let's throw in Twain. We're up to a whopping dozen. My little point is that you can hardly name a dozen essayists in all of history, not because there weren't a dozen, but rather because the essay is the weak sister of genres."

"But I like essays," says Jasmine.

"So do I. It's just that if you had to be locked away with one piece of writing as your company, it probably would not be an essay."

"Why is that?" Robert asks. "Because the other forms are livelier?"

"Beerbohm is pretty lively," says George.

"But not like *Dr. Zhivago*, or *The Tempest*, or anything by Yeats," says Robert.

What we're saying about essays is true, but you can still approach them in ways that are fun for the students. In a course I teach exclusively on the personal essay, I have the students write essays in the form of a menu, a kiss-off letter, a school song, a stand-up comic routine,

and a will and testament. "Let's get down to cases. What is an essay?"

"It's not a short story," says George. "We've been over that—how an essay deals with something that really happened."

"Oh, please let's not get into that again," says Suzanne, referring to a discussion that occurred at our third meeting in anticipation of their writing their personal essays. "I didn't get the distinction the first time, and I won't get it now. I just know an essay and a short story when I see one. Can't we leave it at that? For once?" Everyone laughs.

"You know, George, I used to feel sorry for Suzie, married to you. Now I'm beginning to see your side of the story."

"Of the essay," says Suzanne.

"It's not a column, is it?" asks Inur.

"No, it is not. And you're smart to bring that up. Because people often call newspaper columns essays. They're not essays. Picture an actual column, an architectural column—Doric, Ionic, Corinthian. Remember them? A column in a magazine or a newspaper reads from top to bottom the way you might look at a stone column. It proceeds downward from its topic sentence, and you read it in a straight, unswerving line to its conclusion. There are no detours, no digressions. But an essay requires digressions, depends on them for total effect. A digression in an essay is like a riff in a blues

song. It flies off from the basic theme or tune and then when it has created something wonderful out of itself, it returns to base, which in turn feels changed, heightened, because of the digression."

"Like comic relief," says Donna.

"Precisely like comic relief. Imagine *King Lear* without the Fool. At first you think, what's this Fool sticking his Fool's nose into the play? Then you see the play cannot go on without him. In a way, it's the digression of the Fool that makes *Lear* tragic."

I ask if they recall the scene in *The Catcher in the Rye* where Holden attends a speech class. The teacher tells the kids to yell, "Digression! Digression!" whenever a student speaker wanders from his main topic. "What's Salinger saying here?"

"That digressions are the only interesting parts," says George. In the novel he is working on, the hero's name is Holden.

"But you can't just digress and digress," says Ana. "You'll lose the thread. You'll fly off into space."

"Also like the blues," says Kristie. "You can go away from the tune for just so long, but no longer. Otherwise you'll forget the tune. So will the listener. So will the reader." My thumbs go up again.

"Whatever the subject, we always seem to come around to denigrating journalism," says Nina. "That is, *you* do."

"I know. And I'd be ashamed of myself if I were

capable of human feelings. And in fact I admire lots of journalists. But what they do is not what writers do. As you have already discovered, there's a mystery to the act of writing. You write, yet you don't always understand what you've written. And you're not always understood. And you're never fully understood. And this is a good thing—dwelling in and creating mysteries. But in a column, or an editorial, or a news article, you *must* be understood, clearly and completely. Your words convey a subject. They are *about* something. In real writing the words drift away from the subject. Journalism is communication. It delivers information, even in the form of ideas. If you only do that, you're not writing."

"But don't you think writers need to be in touch with the world?" asks Robert.

I tell him I do think so, but that writers have their own way of being in touch. When Richard Wright wrote *Native Son*, he was certainly in touch with the world of racism, but what gives the book its lasting power is that it is a work of art, and not a polemic. The fact that Bigger Thomas semi-accidentally suffocates the Dalton girl makes him a target for all the categorical hatreds of the time. But when he murders his girlfriend and throws her down a shaft, he becomes a willing killer, and thus oddly more human. James Baldwin took Wright to task for his later books that were nakedly political, because they were too much in touch with the times, and they surrendered to them. The healthiest relationship between a

writer and his world is a vague one, not tethered to specific incidents or specific causes, but rather one that uses those specifics to disclose an abstract truth. Pure thought is contaminated by the news, and by history, too. The real writer uses history only as a moral reminder. He is in touch with the world in his heart. And the world of events is of no greater or lesser inspiration to him than the wings of a katydid.

"Look at the opening of Jasmine's essay. It contains the world, but also so much more." Jasmine reads her first paragraph aloud for us:

> As I sit in my modern English and Irish drama course, I discuss, in a detached manner, my paper topic—the importance of myth and metaphor in Yeats's plays *Cathleen ni Houlihan* and *On Baile's Strand*, and in Synge's *Riders to the Sea*. A topic my professor says is too broad and would be more specific if I focused on the importance of the sea; fertile ground, if I decide to make it my master's thesis. In a hushed way, I mention that I have already begun my master's thesis, although not to the extent I should have. She asks me what my thesis is, and I explain it is on Adinkra symbols. "Where are they from?" she asks. "Ghana," I answer. She muses a bit about how she's never heard of the topic. I bemoan the work that will have to go into it, considering I

have hardly started and it's due in May. "You'll have to go to Ghana." She laughs, and as if I had not remembered myself, I say that I have, and that is where I got the idea.

"That's really great," says Suzanne. "It gives everything about her, including attitude."

"It's such a delicate piece of writing," says Ana. "So clean and quiet. I love this essay."

"Okay," says George. "So what *is* an essay? We've still not defined the thing itself."

"The word comes from France," says Veronique. "As all good things do." She puts on a French smirk. "*Essayer*—to try."

"Very good, Veronique. An essay is an attempt. What's that all about? Poems, plays, novels, *do* something, accomplish something. But an essay only *tries*?" They are quiet.

"Maybe the trying in an essay is what the writer wants to do," says Sven. "He wants to show that he's trying to work his way through something."

"A thought," says Inur.

"A thought. And that's the feeling we get in reading an essay, is it not—that the writer is attempting to discover meaning as he goes along."

"It's what Jasmine gives us, too," says Robert. "The student working her way through the student's life, perhaps toward something more important."

"So the genre is more modest than the others?" says Nina.

"If not," says Inur, "it certainly *appears* more modest."

"Good. Because there's a bit of subterfuge here. Usually the essayist knows pretty much where he's going at the outset. Virginia Woolf knew how big she was going to make her moth when she sat down to write. Yet she wanted to create the impression of learning as she went along." The Woolf essay I refer to is "The Death of the Moth." The Max Beerbohm essay George referred to is "On Taking a Walk." I gave the students both pieces to read at the last meeting, along with Gayle Pemberton's "Do He Have Your Number, Mr. Jeffrey?"

"I think essays are a con game," says Suzanne.

"Definitely," says Diana. "Look at the essays we've read for class. Beerbohm is making fun of those who say that walking is a profound experience. He says he never took a walk in his life, though he has been *forced* to take one. Woolf begins by saying the moth she's observing is so insignificant, it doesn't deserve the name of moth. It's hardly worth her notice."

"They're both setting us up," says Sven.

"That's right," says Inur. "Both writers are telling us they are not writing about anything that matters."

"Yet at the end of the diatribe against taking a walk," says Ana, "Beerbohm says that the very essay we're reading—'such as it is'—was written during the course of a walk."

"And Woolf's moth," says Jasmine, "in its futile battle to stay alive, to stave off death, has grown to the size of a Greek hero."

"Is this what is meant by the attempt of an essay?" says Ana.

"I think so. In the essays we most enjoy, we get the feeling—deliberately created by the essayist—that he is being taken on a guided tour of an idea, and that we are along—"

"For the walk," says Kristie.

"Is Beerbohm's essay a satire?" asks Donna.

"You tell me. If it's a satire, what is it satirizing?"

"Walking?" says Robert.

"Other essays about walking?" says Ana.

"Who wrote a famous essay on walking?" I ask.

"Thoreau," says Veronique.

"So is Beerbohm satirizing the serious advocates of taking a walk?" They ponder the matter. "What is satire?"

"Making fun of something," says Kristie.

"That's the start of a definition. But the satirist is serious too. He's using laughter to get at the seriousness of something he truly believes. Look at Swift's *A Modest Proposal.* Here's the situation: The English are starving out the Irish. Swift, like others, was outraged, perhaps because he was both English and Irish. So what does he do? If he'd written a table-pounding tract on the immorality of the English, how effective would it have been?"

"Not," says Inur.

"But offer up the proposition that if the Irish would just cook and eat their babies, it would put an end to the starvation problem, and everyone sees what is happening."

"Because of laughter," says Suzanne.

"Because of laughter," says Robert. "Hard, bitter laughter."

"Yet the starvation of the Irish was an important issue," says Diana. "Not like Beerbohm. Whether or not you take a walk is just a little joke, a poke at conventional wisdom."

"Aha. So let's return to Donna's question. Is Beerbohm's essay a satire?"

"No," says Kristie. "The subject is too light."

"A satire should attack something important," says Sven.

"Which means," says George, "the satirist must believe in something important the way an essayist does, yet turn it into a joke."

"Good for you, George. No, I don't think old Max's essay rises to the level of satire. He's just having fun. But you're right to make the connection of satire with the essay, because satire is an essay. Only it stands on its head, and sticks out its tongue."

I suggest that there is a fragment of an essay in every form of writing. At some moment in the making of a piece, the playwright, novelist, or poet must think his way through or into an action. He must explain some-

thing. He must take a breath to make sure he's being clear, or that he himself understands what he's saying. Shakespeare does this with soliloquies. Shaw disguised long essays as his plays. "Have you read Adrienne Rich's 'Snapshots of a Daughter-in-Law'?" I ask the group. "It's a very good poem, about being a woman. It moves from scene to scene, from snapshot to snapshot. And it piles wonderful images upon one another. But near the end of the poem, it becomes pure essay. It is as if the poet cannot help herself. After all the elliptical beauty of the snapshots, she must now say plainly what she means."

Suzanne's essay, on her father, evokes a place and an era, which gives us everything essential about herself:

For Dad, I was a boy camouflaged beneath a girl's facade. Dad's ninth birthday gift of boxing gloves and speed bag topped his other Christmas presents: a windup metal PT for the tub and a GI utility belt complete with canteen, bayonet, and combat helmet. Since he'd shown up in my life eight years late, our sparring was as natural as lava eruptions. After arguments Dad looked at me as if he saw an infinite overlay of images twin mirrors make when they face each other. Acknowledging my pugilistic talents, he decided training me in manly arts would develop our relationship. He explained he was just getting me "battle tough" to meet life and the advancing

"Rooskie" menace. While converting Gramps'
root cellar into a shelter, a task somehow sen-
sibly fitting between school air raid drills and
H-bomb tests, he asked me to punch out the
lights of neighborhood bullies. Preparing me to
bloody boys' noses was a thing so forbiddingly
delicious I even forgot how silly red eight-ounce
mitts with white trim and laces looked on me.
The footwork part was exactly like all the danc-
ing I'd done in Grandpa's garage. Turned into
my corner/cut man, Dad became the promoter
for the only female boxer in anyone's memory.

Everyone likes Suzanne's use of "camouflaged"
in connection with the "canteen, bayonet, and com-
bat helmet." We also like the use of the twin mirror
images, and its underlying implication. We cite her use
of "Rooskie"—how complete a picture it paints of the
time and her old man. "As for your new old man, now I
understand why he's so respectful of you."

"Bet your ass," says Suzanne, holding her fists in a
boxer's stance.

Suzanne's essay depends on the power of memory.
We discuss the idea of memory and how it affects and
infuses the writing of personal essays. "Do we ever
remember something as it really was? And when we
discover that what we thought was an accurate memory
turns out to be shockingly false and inaccurate—that

left was right, green, brown, two weeks ago, ten years ago, and so forth—what does that mean?"

"It's more than that memory is unreliable," says Nina; "there's something deliberately distorting about it."

"As if what we remember never happened at all," says Ana. "So a memory isn't actually remembering anything. More like a story made up of something in the past."

"Like a better past," says Jasmine.

"No," says George. "Because memories are not all good."

"Most of them are bad," says Nina, "especially when memory involves our own behavior. It almost always returns as a reproach."

"Maybe we want them to be bad," says Jasmine.

"They're never good," says Ana glumly.

"It's certainly true that memory is no protection against pain," Donna says. "It usually causes pain. But I've often wondered if this wasn't a good thing, after all. Even if you dream up a painful memory, it's only the facts you're distorting, never the feeling. In some ways, I think we punish ourselves with memory, to feel as deeply as we can, to feel pain."

"Like *The Pawnbroker*," says Veronique, referring to the story of the former concentration camp prisoner who pushes his hand down into the long metal pike that holds store receipts, in order to feel anything again.

"But if memories are fiction and personal essays are

made of memories," says Inur, "then we're back to no difference between short stories and essays."

"Except," says Nina, "that we *believe* our memories to be true. We don't consciously invent them."

"I think we may use memory in essays to appear better than we are," says Sven, "even when we paint ourselves as fools or cowards. The recognition of foolishness or cowardice becomes an exhibition of bravery. We fess up. We look good."

"So we create a sympathetic character in ourselves," says Robert, "remembering ourselves as worse than we actually were."

"I think memory is like the imagination," says Diana. Veronique, George, and Jasmine murmur assent. "We remember some things the way we wish they had been, facts suiting our feelings."

"We may be better off *not* remembering when writing a personal essay—at least not making the whole essay out of memory." They ask me what a personal essay should be made of, if not memory. "Something new, something not seen by the writer before. If you try to write an essay about the house you grew up in, you'll only get so far before you start to repeat yourself and run out of steam. But if you begin your essay in a new house, something you're seeing for the first time, your writing will be full of surprises. It will be alive. After you've written about the new house, you then can go back to the old one."

"That's what happens in real life—whatever that may be," says Suzanne. "You see something new and it triggers the memory of something in the past. But that's mysterious, too. It's as if you deliberately came upon the new site in order to bring something back."

" 'The muffled mystery of lost paradises.' " They look curious. "It's a phrase in Dan Halpern's book about writers talking about painters. Camus is writing of Balthus. He says that the most ordinary daily things are heaving with past mysteries."

"Not always," says Diana. "Whenever I'm looking for a subject, I usually screw it up. I think: There must be something in that flower, in that bridge, to carry me into a thought. And as soon as I do that, I fail. The muffled mystery to me is what we were talking about with our short stories—how subjects come to you out of nowhere."

"Because we trust invisible things," says Veronique.

"You know," says Robert, "in reading my classmates' essays, I found that I liked them as people. And I wondered if that was important in the writing of personal essays—to establish yourself as likable."

"Well, you wouldn't want to confuse the charming, delightful, brilliant first persons in your essays with the despicable idiots who wrote them . . ." A round of boos and hisses. "But yes, definitely. If you create a likable 'I' in your essays, the readers will trust you. After that you can take them anywhere."

"There are several ways to be likable," says Inur. "You can be strong-likable, intelligent-likable—"

"Weak-likable," says Jasmine.

"You mean human, frail, vulnerable? You're so right. There's nothing like the confession of human frailty to draw the reader straight to you. Any of you ever read Edwin Muir's *Autobiography*?" They have not. I urge them to get it, not only because Muir writes about himself so gracefully, but also for its appeal to common human frailty. Reluctantly, Muir undergoes psychoanalysis. But through it he finds out something indispensable and right: "I saw that my lot was the human lot, that when I faced my own unvarnished likeness I was one with all men and women, all of whom had the same desires and thoughts, the same failures and frustrations, the same unacknowledged hatred of themselves and others, the same hidden shames and griefs."

"You may make yourself likable simply by creating a situation in which we wish you safety, or happiness," says Diana.

I ask them to look at the Gayle Pemberton essay. I came upon this essay many years ago. I got in touch with Gayle to tell her how I loved it. At the time she was teaching at Princeton. She then went on to chair the African American Studies Department at Wesleyan. We chatted, and became friends. "One of the myths about the social life of writers is that we all hate each other. Not true."

"Who else would put up with a writer but another one of the tribe?" says George.

"You said it. And we all go through the same experiences. I *wanted* to be Gayle's friend because of the woman she showed herself to be in this essay."

She wrote "Do He Have Your Number, Mr. Jeffrey?" when she was working for a caterer in Los Angeles. It takes its title from a throwaway line in Alfred Hitchcock's *Rear Window*. The line is spoken over the phone by an unseen, yet clearly black babysitter, telling Jimmy Stewart that his cop friend is out for the evening. The line could have been spoken by anyone, but Hitchcock chose to give it to a black girl, to indicate servitude and ignorance of the language. Gayle's point was to show how casually, how carelessly, such insults are delivered. I ask Veronique to read the first page and a half of the essay aloud. When she finishes, I ask the class what the writer tells us about herself in describing her catering experience. They say she shows herself as responsible, sensible, loyal, well-mannered, highly educated, sensitive, and alert to her surroundings. "Anything else we know about her?" I ask. They stare. "What does she *not* tell us in the first page and a half?"

"Oh," says Robert. "I get it. She doesn't tell us she's black."

"Why does she wait this long to let us in on this essential piece of information?"

"So that she won't raise hackles," says Ana. "Or prejudices."

"Because she does not trust *us*," says Jasmine.

"Because she's *good*," says Sven.

"Suzanne seems to be writing a little memoir," says Kristie. "What's the difference between a memoir and a personal essay?"

"Not much. Both are written on two levels at once—the events and actions of a life and the emotions they evoke. Both take chaotic material and give it coherence. A memoir is always a memoir. A personal essay can be that, but also something else. It can use memory to make a point, and it is usually more rational. A memoir takes advantage of the irrational. Diana's essay contains something of each." I ask Diana to read from her piece that centers on the Mexican workers on the East End. It is not about the poor Mexicans per se, but rather about her pursuit of an MFA in a world where real people have real problems.

"Were you happy with your essay, Diana?" I usually ask this question of the students after we discuss their work, in part to let them have the last word. A certain amount of self-satisfaction is good for them at this stage, and most of them don't misuse or confuse it with total success. Often they say "no" or "mostly."

"I was surprised how alive it felt writing it," says Diana. "I haven't written many essays, and I guess I always thought of them as spiritless and dry, even plodding. You hear this bass voice in the room—'You've got to sound smart.' But when I got into the piece, it felt no

different from writing a short story. I had the same thrill of riding a runaway horse."

"Diana uses her own life to make an argument or support a cause," says Sven. "So I guess it's part memoir, part essay."

I agree. "But a pure memoir meanders without achieving meaning. It avoids meaning—more like fiction that is real."

"Frank McCourt's books," says Robert. "Rest his soul." Frank was the beloved centerpiece of our writing program for six years.

"Yes. And Claude Brown's *Manchild in the Promised Land*, too, which is called fiction but is really his life. At the end of the book, Brown steps back and recalls being a child and never wanting to leave the front stoop from which he could see all the real and unbelievable things that went on in the streets. 'You might see somebody get cut or killed,' he wrote. 'I could go out in the street for an afternoon, and I would see so much that, when I came in the house, I'd be talking and talking for what seemed like hours. Dad would say Boy, why don't you stop that lyin'? You know you didn't see all that. You know you didn't see nobody do that. But I knew I had.'"

"When one is writing of a tragedy, is it best to simply stay with the facts?" says Kristie.

"Yes. It goes back to my preference for restrained writing in general. If you have the goods, there's no need to dress them up. Your reader will do that for you."

"What do you mean?" asks Suzanne.

I tell them something I have only recently realized: "One thing you learn the more you write is to leave much of the work up to the reader, the way great movie actors leave the work to the audience. Minimalists like James Cagney, Spencer Tracy, Henry Fonda, or today's actors like Anthony Hopkins and Tom Wilkinson—they just say their pieces and the moviegoers fill in the emotions. A good writer does the same thing. If you have something worthwhile to say, and you just say it, plainly and clearly, your reader will add in his or her life, and feel it personally. Your reader will think that it was you who gave him the depth of feeling that's unearthed. But all you did was hint at it. It was he who dredged up the great heartbreak, or delirium, or outrage at injustice. You merely created the sparking words."

"So does the personal essay involve two people at once? Is it personal two ways?" asks Jasmine.

"I hadn't thought of it that way. But I think you're right. Every life contains every other life, just as Edwin Muir discovered. The fact is complicated enough, without overloading it with excess language."

"I wonder if we write to learn that, over and over, about lives containing other lives," says Sven.

"To learn it and to make the best of it. All good stories, fact and fiction, end badly. We write to find out how to live before the bad ending happens."

"How cheerful," says Kristie.

"Which do you think is more true, closer to the truth—an essay or a story?" asks Ana.

"That's an interesting thought," says Nina, "since the essay is supposed to be true."

"In the end, both are true and untrue. You live your life, like Claude Brown. You don't believe a word of it. And you believe nothing else."

Writing Like a Reader

Before we go on to poems—I had asked the students to write their poems for the class after this one—I want to take up a question Robert asked me as we were finishing the last class on essays. At our ninth meeting, I ask Robert to tell the others what he'd said to me.

"It was about the connection between reading and becoming a writer," he says. "Our cranky professor is forever belittling us for how little we read or have read. . . ." Professor Cranky smiles with satisfaction. "But I wonder, does it really matter how well-read a writer is?"

"How well-read was Shakespeare?" says Nina. "Didn't they say he had little Latin and less Greek?"

"Did Donne learn to write by reading someone else?" asks Donna.

"Would that he had," says Jasmine.

"So you think there's no connection between reading and writing? I can prove that's not true. But you may be right in questioning the *direct* relationship. And then there's the special selective way that writers use the reading they do. I don't want you to be overeducated—"

"No danger in that," says Robert.

"I want you to read just enough to do your job better."

"You think the influence of what we read is indirect?" says Ana.

"It is for me. When I was writing my satirical novels, I was rereading Nabokov at the same time. I wasn't reading him for purposes of imitation. I never could be directly influenced by Nabokov since he outstrides me at every turn. He is simply too great a writer. But I did like having him at my side as I wrote. He was good company, the best. It was like hanging around a superior mind. You can never equal that mind, but you strive to do your best, and not to embarrass yourself in his presence. I just wanted him in the same room."

John Updike's idea of influence was more general still. In a pamphlet about *The Writing Life*, he wrote: "Of course, everything you read of any merit at all in some

way contributes to your knowledge of how to write. But my first literary passion was James Thurber. He showed me an American voice and a willingness to be funny. I wrote him a fan letter at the age of twelve, and he sent me a drawing which I've carried with me, framed, everywhere I've gone since." Thurber's "American voice" was probably not the first such voice Updike read, but the "willingness to be funny" is a wonderful phrase to attribute to Thurber, or to anyone, because writing humor is risky business. It takes courage to assume that readers will laugh, especially at intelligent humor. Still, Thurber showed Updike what could be done, not how to do it.

"You're basically talking about inspiration, not direct influence," says Robert.

"That's right. I don't believe that the influence is direct. Some do."

In *Reading Like a Writer*, Francine Prose, clearly a superb teacher of writing, describes how reading certain authors with her students helped things she was writing herself at the time. Going over Joyce's "The Dead" showed her how to write a party scene in which each of the partygoers has something important to say. The stories of Isaac Babel showed her how to set up a story that was to end in catastrophic violence. Babel preceded his violent scenes with "a passage of intense lyricism," to increase the effect of the violence to follow by contrast. Francine followed suit, she writes, and it worked for her. I can see that happening, but it has never happened to

me. I can recall nothing in the authors I have read with my students that I put to use in my own work, either in fiction or in essays.

"To me the writing of others has no greater influence than kisses I've kissed or fights I've fought, or any event that makes an impression."

"But you're always saying good readers make good writers," says Robert. "So where does the making come in?"

"Where was it for you? Every one of you has read something at an early age that made you want to become a writer. Who was it, and why?"

George volunteers. "The first book that made me want to become a writer was a book I was barely able to read. I was five or six when my parents first took me to Glendale's Queens Public Library. I don't even remember the title of the book. It was the subject matter that captured my imagination. I can almost see that book about dinosaurs again, recalling how giddily hard I fell. For me dinosaurs still roamed somewhere in the dark recesses of undiscovered countries, so it was official, adult confirmation of my faith. Books were verifications of imagination. The librarian said the book was too old for me, but my grip on the cover was unbreakable. Dad grinned and said, 'He'll look at the pictures then.'"

"A good dad," says Kristie.

"The moment the book and I arrived home," says George, "I snitched a blank black-and-white marble-

covered composition book from my sister's schoolbag. Leaning on the tin radiator cover, I began copying it line for line, word for word. I was unable to read most of the text. It was the idea of the book more than the book itself that got me. The intoxicating act of writing unknown symbols on paper, leaving a trail for unknown others to follow. When Dad asked what I was up to, I proudly announced to my assembled family, 'I'm writing a book!' " The class cheers. " 'And,' I said, 'I'm going to write books from now on.' My father looked at me a way I'd never seen before, smiling as he patted my head. 'Of course you will, son,' he said."

"What about you, Jasmine?"

"For me there was no specific book that made me want to be a writer. I was drawn to writing because I thought most books were extremely one-sided and told the stories of heroes. But for me, the antiheroes were the more interesting characters, and after reading books I always wanted to know more about them. The first book I can remember inspiring me is Mary Renault's *The Bull from the Sea*, which follows Theseus but not Hippolyta. After reading the book I remember thinking, What would her story be? And what was the history of her people, the Amazons? This book and others like it didn't inspire me to write because they were well written or thought-provoking, but because I've always wanted to write about characters or groups of people that had no story or written history, and to write for them."

"Are those the people you read today?" asks George.

"Books that inspire me today come from different avenues," she says. "Edgar Allan Poe's stories always dig into the minds of unpleasant people, who make his work interesting—"

"That's what you did with your short story," says Kristie.

"—and sometimes I read the fiction in the *New Yorker* just to see what and how contemporary writers are writing. But the authors I most emulate and look to are somewhat opposites, Emily Brontë and James Joyce. I've always preferred the style of Brontë and other Romantics who use pathetic fallacy in their work, while Joyce explores the minds of his characters, making them tangible."

"As in 'Clay,'" says Inur.

"As in 'Clay,'" says Jasmine. "For my writing I want to include nature as a character but also flesh out seemingly ordinary people or antiheroes. I look for authors who would do that. But I have found that while reading shows me what I want my style to include and inspires me to write, it doesn't exactly help my writing."

Donna follows. "Few books littered my home as a kid," she says. "In fact, the strongest memories I have of leafing through bound pages centered around the Sears, Roebuck catalog." Everyone smiles. "Me and my mother, who liked to sew, used to sit side by side at the kitchen table and thumb through its flimsy pages and

assess dress designs. It's less than surprising, with this kind of childhood experience, that my first career was in the apparel industry, peddling garments. My interest in writing came later in life. Shortly after my husband and I were married, his great-aunt died, and along with a mahogany bed, we inherited a fifty-one-volume set of the Harvard Classics, an anthology of notable works in world literature. Some people say reading the collection constitutes the equivalent of a college education, something I had lacked."

"They're *better* than a college education," says Diana, looking straight at me.

"So, when the company I worked for sold off its apparel division," Donna goes on, "I decided to enjoy the luxury of staying home to care for my two babies. In between diaper changes and mealtimes, I dusted off these books and began to read. I learned firsthand from Ben Franklin about his ordeals with civic life in Philadelphia by reading his autobiography. John Locke explained to me his curious theory about sending kids out in the winter cold without enough warm clothing to instill a strong constitution. Charles Darwin described to me his voyages on the *Beagle*. You might say that in some way my love of literature grew out of my love for my children. I just kept reading more and more books for me and for them, for my professors, and for the hell of it. Eventually, I took to writing."

As they recount their early literary experiences, I

recall serving on a panel at Alex Haley's farm in Tennessee many years ago. One of my fellow panelists was Hillary Clinton, whom I'd never much liked because her life seemed so focused and calculated, a wholly political structure. But on this panel, where the participants were asked to describe their first encounters with books, Hillary became a little girl in Illinois, riding her bike to the library. As she told of her first love of books, her face relaxed into a child's, her voice softened. She was in every way beautiful, and I never thought of her harshly again.

Diana says, "It didn't take a particular book to make me want to become a writer. It simply took the act of reading. My mother used to bring me to story hour at the library, where all of us toddlers would listen to a story and then make crafts with tissue paper and lots of glue. At home, she'd read to me from the worn paperbacks she'd read to my older brothers when they were little. At some point during kindergarten, I lay in bed and looked at the pages of *The Berenstain Bears and the New Baby*. The Bears were mainstays in our home literature. This particular story introduced "Sister Bear," a name that my brothers were sure to break out when they'd sing "Happy Birthday" to me in subsequent years. I think my mom had read the story to me so many times that I had it memorized. But I looked from the pictures to the words under the glow of the nightlight. Suddenly, in the middle of a sentence, I knew what the words said. I finished the book. I picked up other *Berenstain Bears*

books. I could read those, too. I wrote my first book soon after: a tale of what happens at the Nativity after Christmas Day. The computer paper, bound with a construction paper cover, was light on text and heavy on stick figures. I proudly carried it to school.

"Now that I could read, I brought home stacks of books from the library. In second grade, I carted around books on the solar system and became a mini-astronomer. I read books that were way over my head—*The Diary of Anne Frank* in third grade. I knocked off three-hundred-page novels in a day. I raced through series like *The Baby-sitters Club* and *Sweet Valley Twins*. I'd get in trouble for staying up late at night and reading. I'd hear my dad coming up the stairs, so I'd turn out the light and hide my book. Usually I was too late."

"You must have been way ahead of the other kids," says Nina.

"My friend Lena was the only person who could keep up with me," says Diana. "And we were neck-and-neck. We'd play dolls at each other's houses, then sit in our own areas of the room and read. And we were both writers: I had a series about a group of girls in Key West, and she wrote about a similar group. I outlined my plot summaries in a little blue notebook. Then I'd wake up on Saturday mornings, sit at the new family laptop, and type. The tales became more elaborate as I grew older: twenty pages, thirty pages, fifty pages, culminating in a two-hundred-page 'special edition' story in sixth grade."

"Holy shit!" says Donna.

"Does everyone agree that girls do this more than boys?" Ana asks. "I don't know how many times I've heard of little Dianas knowing they wanted to be writers from the age of three."

"Boys are backward," says Suzanne.

"All except *us* boys," says Robert.

"It may stem from girls anticipating fewer career choices, until lately," says George. "Writing was a sure way to make your mark in the world because you were only competing with yourself."

"I think little girls are more self-contained. They like the privacy of books," says Inur.

"And the romance," says Ana.

"Boys don't keep diaries," says Jasmine.

"And there's the fact that girls are smarter," says Suzanne. A stiff wind batters one of the windows like a rim shot. We all laugh.

"You said something about the way writers ought to read," says Robert.

"Yes. Because reading is knowledge, and it is possible to have too much of it. As a writer you should know as much as you need to know, but no more than that. Read like a picky thief. Stephen Spender cautioned the young writer to be 'on guard against the corruption that comes from excessive sophistication,' which is the same thing Rimbaud meant when he advised young writers to

toss away their dictionaries, and find their own language. Spender and Rimbaud are all I need to make this point, which would be bolstered and deepened not a whit if I cited a dozen other supporting sources or quoted them in German. Knowledge to a writer is unlike knowledge to other people. It is valuable only to the point of satisfying the writer's artistic aims."

"You seem to be advocating a kind of ignorance," says Nina.

"That's precisely what I'm advocating. As a writer your ignorance is immensely useful to you. With it you find your own way. If you read too much, you won't trust your ignorance. You'll learn everything that is known and nothing that is unknown."

"But isn't it an act of arrogance to dismiss knowledge so casually?" asks Kristie.

"Arrogance or self-confidence, depending on one's temperament. The truth is that writers do not look up to their sources of learning. They look upon them as equals, and that even includes the man of little Latin and Greek. Writers are not passive recipients of knowledge, which accounts for most of us having been very bad students. Of course, Diana is an exception." She sticks out her tongue. "Instead of sitting back and taking it all in, treat the learning that has gone before you as ripe fruit that has been waiting for you to pluck it. In fact, it has."

"The trouble I have with reading too much is envy," says Jasmine. "The best writers make everything look so easy."

"But it's *not* easy," says Nina. "We all know that. So how does one make it *look* easy?"

"Through work." I give them Alexander Pope: " 'True ease in writing comes from art, not chance / As those move easiest who have learned to dance.' "

"You just come up with that stuff?" asks Sven. "Like a *Bartlett's*?"

"You know how kids can sing all the words of every song they hear on the radio? That's how I am with literature. Love it, learn it."

"I think *you* know too much," says Sven.

"Yeats has a quote like Pope's," says Robert. " 'If it does not seem like a moment's thought / all the stitching and unstitching will be for naught.' "

"Robert knows too much," I tell Sven.

"Okay," says Jasmine. "But I still feel more removed from the great writers than akin to them. And I sure don't see myself as their equals. Whenever I read a passage that bowls me over, I think, 'I could never do that.' "

"You may think that. But the passage remains in your mind nonetheless. Because you're a writer, everything you read that you like will stay with you. It's just how it is. Eventually you'll steal it. And I'll tell you something else—that by incorporating a great writer into your work, you are actually saying, 'I *could* do that.' "

"I don't recall the first book I read that made me want to write," says Veronique. "As a child, I found it very difficult to read on my own, so my mother read to me all the time. I loved animal stories, *Lassie* and *Lad*, *Black Beauty*, *My Friend Flicka*, *Trumpet of the Swan*, *Charlotte's Web*, and *Bambi*, which is actually a thick, detailed book, unlike the movie. I loved *The Last of the Wang-Doodles*, *Call of the Wild*, *White Fang*, *Sounder*, and there were countless others which I don't remember. One evening, when I was eight, my parents were entertaining a few people and I remember sitting down at a desk and trying to write a few short stories. That was my first attempt. Later, in sixth grade, I tried again to write a story. I have kept a diary on and off since I was ten, a project started by my fifth-grade teacher. In my twenties, I wrote a very bad play, and in my thirties, I wrote my first novel, not very well executed, but I still like the idea."

"Were your schooldays like Diana's?" Kristie asks.

"I was never very good in school. I lacked the confidence to believe I could write one day," says Veronique. "Until recently, it seemed like an unattainable dream. Now that I'm part of the MFA program, I actually feel that I'll be able to complete a good piece of work."

"There's no doubt about it," I tell her. "What about you, Suzanne?"

She looks up with a helpless expression. "How could someone barely able to read ever hope to become

a writer? My answer was Helen Keller, though I felt a powerful impulse to write before I read her autobiography. I lacked both the method and the nerve. In third grade, I realized my reading ability was different from that of my classmates. Whenever my eyes traveled the land of books, without warning, letters would reverse themselves abruptly, nose-diving off the page, preventing me from locating where a sentence started or ended. The rote practice of reading aloud confused me completely, further eroding my already meager confidence. I could never finish a paragraph. Today's educational system would likely place me in the ranks of those suffering profound forms of dyslexia, but in New York's public school system of the 1950s, I was dismissively labeled a 'slow learner.' Sentenced to spend eight years in PS 138's back rows, it took me hours to get through just a few pages of the simplest books.

"But Miss Keller's book convinced me for the first time that I would be able to write. Through touch and vibration, she opened a universe of written expression to me. When her teacher placed Helen's hand on her heart, demonstrating communication beyond words and symbols, I felt that I too might be heard. When I read of Helen's indomitable determination, in her own words—'those who bear their burdens as if they were privileges'—how she was able to write without sight or hearing, I was inspired. Only a powerful emotional connection to certain authors' narratives pulled me through.

What Ms. Keller began led to my counting Anne Frank, Victor Hugo, Charles Dickens, Charlotte Brontë, and Emily Dickinson among newfound friends."

"Did your folks encourage you?" asks Jasmine.

"Progressive downward spirals caused our family to move into ever more dangerous neighborhoods," Suzanne says. "Several of our apartments overhung decaying storefronts on streets where crooked buildings pushed together meant cheaper rents. Libraries were quiet places of refuge. Solidly faced buildings of brick, they were always warm and well lit. Order imposed by Dewey's decimals, coupled with furniture smelling of Murphy's oil soap, gleaming bathrooms with scrubbed tiles, sparkling mirrors and fresh paper towels, were all proof their welcome was sincere. Since books were kryptonite to the rest of my family, as soon as I learned our new address, I would send a letter to myself. In the post office, depositing the envelope in the metal mouth marked 'In Town,' I was never sure I could move my hand out of the mail slot before the cover snapped shut and took off my fingers. I waited for that card with each mail arrival as if it were a passport, positive proof I was a member of the community of thinkers."

"Amazing," says Ana. "Wonderful."

Inur's turn. "In high school," she says, "at the end of the school year, all the lockers had to be cleaned out. Locker clean-out was organized by grade. Seniors, who were on the first floor and wore the coveted blue blazers,

went first, while freshmen, who were easily spotted on
the third floor in their maroon blazers, went last. Dur-
ing locker clean-out, the trash overflowed with loose-
leaf binders and spiral notebooks still filled with the
year's notes. Some kids were brazen enough to discard
textbooks. Whatever didn't make it into the trash was
left on the floor. I would roam the halls afterward to
see what was left behind. I found four copies of *Hamlet*,
three copies of *Night*, and two of *Macbeth*. My greatest
find was discovering a copy of *A Streetcar Named Desire*.
At the time, I was unaware of who Tennessee Williams
was, and what *A Streetcar Named Desire* was about. All I
cared about was finding out who was the shirtless man
on the cover. Was he an actor? Was he the author? But
more importantly, did Marlon Brando still have that
body, and was he single?"

"Yeah!" from the women.

"Okay, Robert." I point to him. "You started all this.
What do *you* think the connection between reading and
writing is?"

"Oh," he says. "I just wanted to hear from the others."

"No, you don't. Spill."

"Well," he says, "since I labor in both the dungeon
of daily restaurant drudgery and the mines of weekly
journalism, most influences on my work operate in the
metaphysical arena of addition by subtraction. I read a
lot of commentary on food and sports, and then make a
daily novena to Sister Regina della Cucina, patron saint

of cooking and concision. So far, so good. I was a preco-
cious reader as a child, urged on by the intellectual aspi-
rations of my college-educated mother, and the severe
rule (and equally severe rulers) of the Little Dominican
Sisters, who lacked charity. It was expected of my moth-
er's children that we would read 'above grade level' from
kindergarten onwards. When I was in the seventh grade,
test results showed I read like a twelfth-grader. Armed
with this information, I asked if I could take Marybeth
Keegan to the movies by myself. I quickly learned the
difference between reading like a twelfth-grader and
being treated like one. I wrote poetry as a kid, probably
because it seemed easier than fiction. The nuns were
delighted, and this only served to solidify my reputation
as a sensitive child."

"Which you still are," says George.

"Maybe," says Robert. "But on the whole, I would
rather have been a juvenile delinquent. I frequently
turn to poetry at day's end, in spite of Wallace Stevens's
exhortation that poetry, like prayer, is best enjoyed in the
morning."

Kristie looks at me. "What about *you*? Was there an
author or a book that got you going?"

"Not a book. But a moment." I tell them about my
grandfather, my mother's father, who had gown up as an
artist in Berlin. When he brought his family to America,
the only work he could get was as a sign painter—elegant
hand-painted signs for stores and other businesses in the

Bronx, where he set up shop. He would ride the Third Avenue El to and from work, returning to my grandparents' tenement apartment on St. Mark's Place in downtown Manhattan. But at least twice a week, he would stop at my parents' apartment in Gramercy Park before returning home. He would come to read me stories when I was three or four years old. Or he would tell me stories he made up, sitting at the end of my little bed. My grandfather, whom I called Patta, looked like a gentle patriarch, with white hair, high cheekbones, and mirthful eyes.

"One night he sat with me and said nothing. I asked him, What about my story, Patta? He said he was tired that night, and would I tell *him* a story instead? 'But I don't know a story, Patta,' I said. He said, 'Sure you do. What did you do today? Tell me that story.' It happened that on that day one of the mothers of the neighborhood had taken a bunch of kids to Palisades Park in New Jersey. So I told Patta what we had done at the amusement park—the water rides, the cotton candy. I had my first jelly apple, I told him. I narrated my day. He seemed amazed, enthralled. And so I lengthened the story, and made stuff up, about red waterfalls, and wild speeding boats in the shapes of turtles. All sorts of things. And my grandfather's eyes got wider and wider, and he looked at me as if mine was the only voice in the world.

"That's when I learned what power a writer has. I never wanted to give it up."

"What exactly is that power?" asks Sven.

"I had made my grandfather see what I had seen, with words. The first task of a writer is to make the reader see. And I had done it."

"First you indicate that you think that reading is no different from any experience a writer has," says Robert. "Then you suggest that it's special and indispensable."

"It's not different from other experiences in terms of what it teaches. You learn from a war. You learn from a love affair. You learn from a book. A year spent in a rain forest is at least as useful an experience as reading a book, especially one about a rain forest. What I mean by reading being differently useful to writers is that it embraces us with our own world of thought and expression, like our mother tongue. Other worlds may be interesting, fascinating, even enthralling. But in none of these others are you wholly free. The artist is the only free person. You are free when you read. You are free when you write."

I tell them about a poetry reading I went to in Moscow in the late 1980s. Andrei Voznesensky was the main attraction. There were 14,000 people present, the size of a crowd at an American college basketball game. "Why do you suppose all those good Communists showed up to hear Voznesensky read?"

"It was a way to be free," says Inur.

"It was a way to escape," says Ana.

"And it was a way to be themselves. Watch people you love in the act of reading. Never will they look more

beautiful than at that moment. Sometimes I sit with my granddaughter on the couch, both of us reading. I am aware of her silence, how sublime she looks."

"Are writers really that different from other people?" asks Sven. "It makes me uncomfortable to think so."

"Sounds undemocratic," says Jasmine.

"Democracy has nothing to do with it," says Suzanne. "He said 'different,' he didn't say 'better.'"

"We *are* different. Writers do not give up on people. When characters in real life cease to be interesting because they seem to fall into categories and are subject to easy generalities, people no longer pay attention to them. That is precisely the moment when writers pay the keenest attention to them, for there is nothing stranger than the ordinary-seeming man. Either he is more honorable, or more treacherous, or more anything else than he appears, but he is never *what* he appears.

"And this world of ours is not comfortable." They sit back and smile, ever amused to watch me on a roll. "It is strange, full of strangenesses. Writers do not seek what other people seek, no artist does. Other people seek what they feel most content and comfortable with, whereas writers do the opposite. We seek anger, dread, the event that rocks us back on our heels. The world of the writer is the world of shadows and howls and bloodstains. Our senses are different, our memories different. I seem to remember only the strangenesses in my life—

the doctor with the German name in Westport, Connecticut, where my family vacationed when I was five, the one who shot kittens in his basement; the tormented girl in my school who, in a fight in the girls' locker room, bit another girl's finger to the bone. A thousand more, all of the same sort. These are the subjects writers husband, and cherish. Let others go for quilts and hot chocolate. We covet shit and guillotines."

"If a writer profits from close reading," says Donna, "does he prefer writing for other writers? Is the writer's relationship to the reader who is not a writer different from one who is?"

"I don't think writers write for other writers," says Nina. "Writers are too finicky."

"Yet other writers can appreciate things that ordinary readers can't," says Inur.

"I think regular old readers appreciate many of the things writers do," says Sven. "They just don't make a big deal of it."

"It's interesting. You read something you admire as a writer, and you tend to take on the skin of the person who writes it. You see how the writer came up with what you're reading. You can sense another mind making this choice and that. In that way, every time you sit down to write, you're in the company of writers who have written before you. No one writes alone. I don't know. The more you write the less you may enjoy the act of reading. On

the other hand, the more you lose yourself in someone else's book, the less you may feel like writing one yourself."

"So good readers make no writers?" asks Diana. I walk around the table and bop her on the head.

A Fine Frenzy

U p on the green blackboard go quotations from
Samuel Johnson's *Rasselas*, and from Shake-
speare's *Midsummer Night's Dream*. I often
write quotations on the board before a class meeting.
Sometimes I refer to them during our discussions, some-
times not. I mean them to serve as epigraphs to the work
that follows, as if each class were a chapter in a piece of
writing. From Johnson:

> "The business of a poet," said Imlac, "is to
> examine not the individual but the species; to

remark general properties and large appearances.
He does not number the streaks of the tulip, or
describe the different shades in the verdure of
the forest; he is to exhibit his portrait of nature,
such prominent and striking features, as recall
the original to every mind; and must neglect the
minute discriminations, which one may have
remarked, and another have neglected, for those
characteristics which are alike obvious to vigi-
lance and to carelessness."

From Shakespeare:

The poet's eye in a fine frenzy rolling,
Doth glance from heaven to earth, from earth to heaven;
And as imagination bodies forth
The forms of things unknown, the poet's pen
Turns them to shapes, and gives to airy nothing
A local habitation and a name.

Earlier I suggested that teaching is like publishing
something you write. The use of my epigraphs suggests
that it is also a little like writing itself. A class is a book.
You begin a semester with a general idea of where you
want your students to be at the end of it. In the Writing
Everything class, I know I must spend so much time on
short stories, so much on essays and poems, and leave
room for at least one session before the course is over

to see how far we've come. There is no point to a writing course if the students do not write better at the end of it than they did at the beginning. Everything you put into teaching the class week by week has that as its aim. Come May, the same people will sit in the same white room at the same white table before me. They will appear exactly the way they looked four months earlier. But like the landscape, they had better be changed.

In a way, they evolve like characters in a story. They have minds of their own, and will go where their minds lead them. You as teacher or writer need only determine where these characters want to be, what they want to achieve. You're Virgil, not Dante. It's *their* adventure. What you must do is make sure they do not lose sight of their own goals, and try not to substitute your goals for theirs. Your understanding of your students deepens the longer you're with them. The better you know them, the better you get at helping them be themselves, just like fiction.

And the mystery of writing appears in teaching, too. I will enter a classroom with a plan of things to say. No sooner have I embarked on my straight and narrow than a student—George or Sven or Diana—will bring up another subject from left field, and at once I will veer in that new direction, never to return to my original map. In the very least, it makes for better theater this way, more nervous, more alive. We all remember with a shudder the teacher who lectured from the same yellow-

ing notes year after dreary year. Better to use no notes at all, to create a high-wire act in which the students join you on the wire and nobody knows if we'll make it safely to the other side. To be sure, I may permanently forget whatever it was I originally planned to say. But it is much more exciting to allow oneself to be swung into a new and foreign path, just as in writing when you find yourself in the middle of the strangest sentence, and wonder how you got there.

It is week twelve, late April. The men are in shirt-sleeves, the women in colorful outfits. Green has returned to our window view, and a warmer light.

They have written their poems, which we distributed at the last class. They take to writing poems, though none in this group plans to be a poet. I applaud their enthusiasm, but I confess I'm growing tired of modern poetry, and of the qualities that make it modern—principally the poet's responses to the impetus of small events. I acknowledge the gifts of the moderns—their ability to make something great out of something small. But in the end, it is the smallness of even that greatness that is beginning to wear on me. I cannot forever read about Lowell's mind not being right, or even about Marianne Moore telling me that the mind is an enchanted thing, or about Richard Wilbur telling me that the mind is a bat. And these poets are among the best of the lot. I am far more interested in the general moral behavior that was the subject of Johnson, Gray, and Cowper in the eighteenth century,

of which I never seem to tire. In the end I prefer to survey mankind from China to Peru than to stare at a single representative in the act of losing his marbles.

What it comes down to is my feeling that most of modern poetry is not all that important. I did not always feel this way. When I toted around Louis Untermeyer's anthology in high school I was steeped in the poets of the day, and wanted to join them. Nothing was more enchanting to me than their reactions to things, coupled with their ability to address my secret sins and darkest shames by expressing their own. But as I grew older, the time-tested heroic themes came knocking to remind me of their staying power. The last lines of Tennyson's "Ulysses," which I used to quote to illustrate their unthinking simplicity as compared to Joyce's *Ulysses*, or to Robert Graves's "Ulysses," I now hear as meaningful and true: "One equal temper of heroic hearts" vowing "to strive, to seek, to find, and not to yield." Czesław Miłosz, in a poem called "Preface," said that "serious combat, where life is at stake, / Is fought in prose." Then he added, "It was not always so." I find myself yearning for the poetry of serious combat. Is this what Yeats meant by "This is old age"?

Yet my students plunge in happily. For most, if not all, poems probably represent their original introductions to literature. They grew up on nursery rhymes, Mother Goose, "The Walrus and the Carpenter," Lewis Carroll's nonsense poems, Edward Lear's limericks, and

so on. They can recite poems. They have their favorites. (Kristie will rattle off "Jabberwocky" at the drop of a hat, which no one drops.) For this, the ninth week of classes, I have asked them to bring in a poem by a poet they admire as well as their own work, and they have no trouble producing three or four in a crazy salad that includes Wordsworth, Ted Kooser, Linda Pastan, Wallace Stevens, Yeats, Emily Dickinson, Frost. More than the other forms, poetry speaks to them directly. It may be the most difficult form to do well, but it is probably the easiest to do at all. In my Modern Poetry class, I have the students write a love poem, to get the feeling of how the poets they're studying deal with the subject, and even the least experienced of them does a fair job. This may be because poetry is also the music of the genres. No work of prose, no matter how beautiful, is aptly called a song.

There is also something less threatening about poetry. It seems to be conjured up and conceived in a space so removed from the world that the world, however admiring of it, does not take it seriously. Thomas Hardy said that if Galileo had announced in a poem that the earth moved, the Inquisition might have let him be. And yet poems of the ages go on and on, differentiated from prose by an ethereal quality derived from elliptical thought and their deliberate avoidance of understanding. A poem should be at once clear and mystifying—

in Shelley's terms, "the words which express what they understand not." Prose, on the other hand, strives to be understood, especially in its own time, which accounts for both its strength and its weakness. In that same poem "Preface," in which Miłosz conceded the power of prose, he said nonetheless that "novels and essays serve but will not last," as compared to the weight of "one clear stanza." It may be that poetry is favored by my students, including those who do not write it or intend to, because it seems like history's protectorate, kept safe for no other reason than its aim of beauty. In ancient Ireland, poets were called The Music. When one king would attack another, he instructed his soldiers to slaughter everyone in the enemy camp, including the opposing king. But not The Music. Everyone but The Music. Because he was The Music.

Another thing about poems: if you write a bad one, it doesn't mean you're a bad writer. Yet if you write a good one, it is certain to show what a good writer you are. We take up Diana's "Small Bursts" first:

It's the usual Sunday night slump
and I begin by failing
the way I always do:
throwing words everywhere—
ringing against the walls with
lots of—(one will fall

into that space, you wait) but little sense—
hoping that something
hits. Hits hard.
On the phone, Mike tells me to write
about the epic march of
Binghamton basketball to
Memphis to join the NCAA dance
about a man he's just made up
who has bet nearly his life
on a losing game,
the wife who will leave this man. . .
This is his love story, not mine,
but if it were I would tell it
in small bursts like
balls bouncing off wood:
a screech, a shout, a thud on rim,
the pause, the fall.

In spite of the "I'm just a kid" impression she makes,
Diana is a first-rate writer, and all grown up. After the
group says how much they like her poem, we look closer.

"Why does Diana use the word 'slump' to describe
her inability to write?"

"Applies to sports," says Sven.

"Does she get out of her slump?"

"That's the trick of the poem," says Veronique.
"There's a love story, not hers, so she won't tell it. She's

still in her slump. But if she did tell it, hypothetically she would tell it 'in small bursts.' So she tells it without telling it."

"How much do you need to know about sports to appreciate the poem? Do you know what the NCAA 'dance' means?" Some do, some don't. We talk about why the national collegiate basketball tournament in March, "March Madness," is also called the Big Dance—how some schools are invited, and others not.

"The gambler that her friend Mike has invented," says Jasmine. "He's doing a different dance."

"And a distant dance," says Ana. "There's the poet, and her friend, and the man her friend makes up. The poet doesn't want to get close to her own subject."

"I love the final image of the basketball shot, a buzzer shot rimming the basket, going in then out," says George.

"Why does Diana mention Binghamton?" I ask.

"Because she went there," says Suzanne. "Mere boosterism." Diana chuckles. "No, I'm kidding. I think she gets Binghamton into the poem because the school is a long shot to make the tournament."

"Unheard of," says Diana.

Robert adds, "A long shot like the shot at the end of the poem."

"Like finding the lightning word in something you write," says Inur.

"Just like that." We look at Ana's poem, called "OK":

He said, "Let's go to my place."
I said OK.
He drove as I looked straight ahead.
Oncoming lights.

I said, "There's something I must tell."
He said OK.
He drove ahead and then I said,
"My breasts are gone."

He said, "That's quite OK with me."
I thought, "My God!"
We drove ahead into the night.
I fell in love.

"What's this one about?"

"Acceptance," says Nina.

"Love without judgment," says Suzanne.

"And you know it's about love because she says, 'I fell in love.' Right?" They nod. "Do we know that she fell in love without her using that line?" Most think yes. "When he says, 'That's quite OK with me,' does he indicate he's worthy of her love?"

"I don't know that the last line is necessary," says Kristie.

"I'm not sure it is. If you tell too much in a poem, you trample on its implications."

"But if I don't use it, what do I put in its place?" Ana asks.

"You may think of something. But would it be so terrible if you put nothing in its place and the poem ended on their drive into the night, into the unknown?"

"A three-line stanza in contrast to the others, to suggest something unfinished," says Donna.

We go back and forth on the question of Ana's maintaining or dropping her "I fell in love." I ask if the ideas of acceptance and love without judgment are what they like most about the poem.

"I don't think it's about love without judgment," says Robert. "We see the poem from her point of view. The guy may simply be saying he doesn't care about her breasts as long as he gets laid."

"But she wouldn't have given an easy 'OK' to his invitation if he hadn't shown nobler qualities," says Kristie.

"Ever the romantic." Inur smiles at her.

"We know that Ana wouldn't have given an easy 'OK' because we know what an elegant, discriminating lady she is," says George.

"Ain't it the truth," says Ana.

"What I like most about the poem is the setup," says Sven.

"Me, too," says Donna. "I see the two of them facing forward in the car, so intimate yet not looking at each other."

"I'd like to discuss Inur's poem," says Jasmine. "To get a different view of love." Inur smiles at her friend, and blushes. She reads her untitled piece:

The warmth of your hand on my thigh burns,
It is your touch which makes my heart race,
And causes something in me to yearn,
For you to respect my personal space.

Your sweet words fill the air,
When, to me, you speak,
Ever so softly and with delicate flair,
Yet my only thought is of how you reek.

My soul cannot lie,
But I will,
And so I do not look you in the eye
When I say I love you still.

Inur's poem presents a typically thorny problem for
teachers of writing. When the subject matter is per-
sonal but witty or has a relatively happy ending, like
Ana's poem, it is not uncomfortable to speak of the
writer and the thing written as one and the same. But
when, as with Inur, the piece is about a deep personal
quandary, you have to be careful to suggest a distance
between writer and subject. Of course, the distance is a
pretense—everyone knows that—but preserving it is the
right thing to do. Inur may have put her life in her poem,
but that should not be the same as exposing it to public
inspection. My class is very careful with one another's

feelings, and it treats its confessions as a trust. Still, here is a place where teachers must be alert to the possibility of injury, and be sure that we are talking about a poem not a person.

"The idea that it is his touch and not himself that makes her heart race—that's great," says Suzanne.

"The sweetness of his words as opposed to the way he 'reeks,'" says Donna. "Also great."

"Oh, no man smells good," says Ana, causing the four men in the room to sniff their armpits dramatically.

"I loved the pun on 'lie' in 'My soul cannot lie, / But I will,'" says Veronique.

"What I liked especially was the word 'still,'" says Nina. "It shows him doubting her love in spite of all his affectionate moves. He knows she mistrusts her lover, no matter how she answers him."

"Poetry is all contradiction, isn't it?" says Jasmine.

"Mostly. One thought clashing with another."

"Held together by the poem," says Kristie.

"Does that mean we believe in contradictions?" says Nina. "Things continually at war with one another?"

"Only in discontinuity do we know that we exist. Robert Penn Warren said that in a poem called 'Interjection #2: Caveat.' Warren actually opposes continuity and existence."

We read a poem by Nina, called "I Do the Worrying Now":

I've been out in the garden pulling weeds, if you have
 to know.
It hasn't been too much for me. I'm fine.
I know it's January, but it's been warm.
Those weeds—you know the ones—
with shallow roots—the leaves are like geraniums?
They're coming up all over.
I saw them from the window when I was drinking my
 coffee
so I just went out and pulled a few.
It didn't do me any harm.
I know what I can do and what I can't do.
They would have choked the myrtle.

"Precision and restraint," says George, looking at
me. "Just what the doctor ordered."

"Beautiful," says Kristie.

I think so too. "And like so much of modern poetry,
Nina's makes something of an event in the present. The
poet is occupied with this, and she makes that. She sees
what is present and calls upon what is absent."

"Like Wallace Stevens's 'Snow-Man,'" says Robert.
"Seeing the nothing that is not there and the nothing
that is."

"It also sneaks up on you. Poets do that deliberately."
I tell them about a poem I had pinned to my bedroom
wall in high school—Robert Francis's "Pitcher." I put
it there because I was a pitcher on the baseball team,

though no better at that than I was at poetry. "His art is eccentricity," Francis says about the pitcher, whose intention is "not to hit the mark he seems to aim at," thus to trick the batter and make him "understand too late." This takes as much calculation as natural talent, and a great deal of practice. You look as if you're throwing a fast ball when you're throwing a changeup, a slider when you're throwing a curve. In a way, the poet is always throwing a curve. "If Nina's poem were an essay, what would it be about?"

"About ten pages," says Diana. "And please don't bop me on the head again."

"It would be about simplifying one's life," says Veronique.

"It would be about knowing one's limits," says Ana.

"It would be about order over chaos," says Donna.

"I don't know what it would be about," says Suzanne. "That's the difference between a poem and an essay." She gives me a grin.

"You know what I notice about all our poems?" says Kristie. "They're not difficult to understand. So many modern poems I read are like puzzles, impossible to get without someone explaining them to you."

"I don't think difficulty is absent in our poems," says Jasmine. "They're just not impenetrable."

That's a valuable distinction. I give them the example of song lyrics that are both clear and deep, such as the last lines of Cole Porter's "In the Still of the Night"—

". . . like the moon growing dim on the rim of a hill, in the chill, still of the night." The longing of "Do you love me as I love you?" is made deeper by the internal rhymes. They break your heart.

Once in a while I'll look up from an idea, as I do now, and see my students staring straight ahead. Something about Cole Porter has touched them, and they are lost in their private thoughts. They are not really themselves when they enter a class. They adopt the role of "student," leaving their lives at the door of the college. But occasionally, something strikes them at the core, and the outerwear that goes with being a student is shed. Sometimes they bring personal pain with them. Early in the term Veronique suffered the death of a lifelong friend, and her face bore that sorrow in class. Sometimes an emotion will hit all of them at once. I can see the effect of Porter's song on each of my students, as it reminds them of their own longings. These are tender, melancholy moments in a teacher's life, and they don't last long. You wouldn't want them to. The student's mask is useful to them and to you. You both function within the deal you make to teach and to learn. But for a glimpse or two, it is very nice to see my group for the sweet, suffering people they are, alone with their lives.

"People tend to make more grand statements about poets than prose writers," says Nina. "Legislators of the world, and so forth."

"There is a kind of assumption that the poet knows

the truth about things," says Ana. "And even if that same truth is known by the novelist, the poet gets to it faster."

"Maybe that is why poetry rises to a special place above the other genres—because it grapples with the difficulty of knowing the truth." I indicate the blackboard. "Small wonder Shakespeare yoked together the lunatic, the lover, and the poet. Poets not only embrace uncertainty, they construct their works of art in a way that ensures an appreciation of uncertainty. Everything important in life is unknown."

All this requires both attention to life and respect for life, the way children look at things. Poets may not be formally religious themselves, but they are religious as writers and observers of the world. The disinterestedness by which the poem comes into being is like God's. And like God, who seems to be defined only by his own existence, the poet remains only himself, admiring the world of his subject matter—also fearing, loathing, and adoring it—standing back and "paring his fingernails."

Inur asks, "So, what is truth—"

"—said jesting Pilate," says Robert. "And would not wait for an answer."

"Truth is beauty, beauty truth," says Kristie. "I just made that up."

"It's all too vague for me," says Sven.

"A poet tries to identify a situation or an emotion as accurately as possible. To name it, nail it, so that the thing and his description of the thing are virtually the

same. At the same time, the poet knows that perfect identification is impossible. I think that's where imperfection is the same thing as divine."

"Woody Allen said that God was an underachiever," says George.

"What does it mean to identify an emotion or a situation accurately?" asks Ana, indicating the quotation from *Rasselas* on the board. "Isn't it accurate to count the streaks of the tulip? Johnson seems to think that's not enough."

"It can't be enough. Otherwise a poem would be so private in its subject matter or its references, it would be useless to others."

Robert's "Digging Out, January, 1954," makes that point. It is an elegiac poem about growing from boy to man. I read a few lines:

Toward the watchful, blue-white eyes
of humming, arched streetlamps,
their steamy, whiskey-sweetened breath rose silently,
as they stooped over the scraping
of heavy handled steel shovels,

Then I ask him what he would think if I rewrote them this way:

Toward the eyes of streetlamps
their whiskey breath rose

as they stooped over the scraping
of shovels.

"What would I be doing, Robert?"

"Removing the adjectives and adverbs," he says.
"You like it better that way?"

"Sure he does," says Sven. "The nouns stand out."

"My, my! Am I actually teaching you people some-
thing?"

"No!"—from five or six.

Robert indicates that he'll think about my revision,
which is enough for me. I prefer the undressed-up style
in everything, as my students know. But if I had foisted
my preference on Keats, there would have been no
Keats. And "rosy-fingered dawn" is a hell of a lot more
beautiful than "dawn." What I can do, especially with a
writer as good as Robert, is to offer choices, and leave
it at that.

"Why are poets so sad?" Donna asks. "Our poems
aren't, not most of them. But the published poems I read
are nearly all tear-jerkers."

"Do you think poets are sadder than other writers?"
I ask.

"They kill themselves more often," says Ana. "Sylvia
Plath, Anne Sexton, John Berryman."

"So many poets go mad," says Robert. "Do you think
that it helps one's writing?"

"I wouldn't recommend it."

"I think poets are more high-strung than novelists," says Nina.

"Could be, though if you talk with Richard Wilbur or John Ashbery or our own in-house poet, Billy Collins, you might confuse them with solid, golf-playing citizens who happen to write poetry."

"I wonder if there isn't something fundamentally hysterical about poetry," says Suzanne. "Poets may live in an agitated state, and then calm down in their poems."

"I doubt if poets are sadder or more high-strung than prose writers. But their personas may get on their nerves. Prose writers don't really need a single persona. Every essayist can have two or three. And fiction writers can spread themselves among a thousand different characters. The poet living with his persona all his life may recognize the growing disparity between his controlled self and himself. The final contradiction of a poem is that it is controlled hysteria."

" 'A fine frenzy,' " says Donna.

They collect their papers, and we are about to disperse. But I don't want to leave the subject of their poems without indicating that I think an essential element is missing in nearly all of them. "Before we drown in self-congratulations, I want you to consider something."

"Uh-oh," says Kristie.

"Every one of you is adept at milking the moment. You're clever, you're precise. By the time you've reached the end of your poem, you've covered the moment you

started with from every angle. What I'd like you to do now is to train your minds to get off the precipitating moment of the poem and make something larger of it—wider and deeper. Treat the moment as you have done. Then stand back, breathe, and see what thoughts the moment generates."

"You mean we haven't seen all that we ought to see?" Diana asks.

"You've seen the thing. Now find the other thing. I think you'll discover that you've written a much more satisfying piece of work."

Ana feigns a huff. "So, just as we were about to head home assured that we're all poetic geniuses, you tell us to start over from scratch."

"That's right."

"You're impossible," she says, eliciting a general agreement.

"I have a new poem," says Kristie, "for the arrival of spring."

Roses are red
Violets are blue
But Roger thinks "roses" and "violets" will do.

Seven

Parting Shots

Wouldn't it be nice if you knew that your teaching had shape and unity, and that when a semester came to an end, you could see that every individual thing you said had coalesced into one overarching statement? But who knows? I liken teaching to writing, but the two enterprises diverge here, because any perception of a grand scheme depends on what the students pick up. You may intend a lovely consistency in what you're tossing them, but they still have to catch it. In fact, I do see unity to my teaching. What *they* see, I have no clue. It probably doesn't matter if they

accept the parts without the whole. A few things are learned, and my wish for more may be plain vanity.

"You know what I hate about writing," says Suzanne. "It makes me crabby."

"Crabbier," George corrects her.

"I get into something I'm writing," she says, "and I lose patience with family, friends, and, of course, *him*."

"You haven't begun to know crabbiness in writers." I tell her about the time Faulkner sent the manuscript of *Absalom, Absalom* to his editor. The editor was on vacation, so the manuscript was read by an assistant who returned it, complaining that Faulkner's sentences were too long, his plot murky, and the whole thing a mess. Faulkner fired back a five-word telegram: "Who the hell are you?"

We are having drinks before our reunion dinner at Robert's restaurant in Water Mill. It is late February 2010. I didn't have to inveigle Robert, after all. Good guy that he is, he offered his place to the class, and we jumped. Our final meeting of the semester last May had begun with a lofty discussion of their artistic aims, and soon disintegrated into plans for their summer vacations. There is nothing like the light on eastern Long Island in late spring. By the time the class ended, we all were stealing glances at the bright windows and hearing the ocean in our daydreams.

Now, patches of snow cling to the ground around Robert's. The restaurant occupies a handsome yellow-

shingled house on the south side of Montauk Highway, which cuts through the center of Water Mill, between Southampton and Bridgehampton. The town has a windmill on its green. A stagecoach stop in the 1670s, Robert's retains an antique country feel, with small windows, candlestick wall lights, little sand-colored lampshades, wide-plank floors, dark beams on the ceiling both bearing and decorative, two fireplaces, and a large, wide, gleaming wood bar. The dining area is an L-shaped room, with a dozen tables, and a private room with an open entrance is framed by more beams. Here Robert's staff has set up a round table for the twelve of us. Only Nina couldn't make the dinner. Excited to see one another after a year, the students talk nonstop as soon as they take their seats, occasionally acknowledging that I am here too.

"How's the book about us coming?" asks Diana, who is all dressed up tonight in black slacks and a black sweater. We are seated at the round table, chatting before dinner.

"Oh, I've chucked the book. The characters were too flat—boring, if you know what I mean."

"You better treat us right," says Sven.

"What are you going to do, beat me up?" I smile my old man's smile.

"Has it been hard to write?" asks Veronique.

"It would have been, if I had used things you actually said. But the stuff I made up is so much better—

brighter, funnier—than could ever have come out of your mouths."

"So you're finished?" asks Jasmine. "I guess it's time to call the lawyer."

"Class action," says George.

"I hope you included all the things you learned from us," says Jasmine. "Teachers always say how much they learn from their students."

"They must have different students."

"Did you ever feel you couldn't do the book?" Kristie asks. She too is dressed for the party. All the women look aglow.

I tell them about a conversation last week, with my three-year-old grandson James. He looked at a bunch of papers on my bed. "What are you doing, Boppo?" he asked.

"Writing a book about teaching people how to write."

"But people already know how to write," said James. "You don't need to teach them."

"To James!" says Inur, raising a toast. In the year since our class, she has married a lawyer and lives in New York. After a day of appointments in the city, she made the two-and-a-half-hour drive to Robert's to be with us.

"Are you writing?" I ask her.

"I'm starting to write again," she says. "It's been a while. I don't have a job now, so there's plenty of free time."

She has her right arm in a cast, from a fall on the ice. Suzanne helps her cut her food. When Inur entered the room, we all laughed because Veronique had arrived a short while earlier with her *left* arm in a cast. She dislocated her shoulder in a fall down a flight of stairs. Veronique announces to the group that she's in love. "At forty-four! At last!" Inspecting her arm, George croons, "Falling in love with love."

Jasmine is looking for work in publishing and has a nibble from a Long Island magazine. She is writing "every single day," she tells me. I forgot how fresh and sweet her face is. Her hair is done up in bright ringlets.

We raise our glasses to Robert. His play, *Alternate Spaces*, will be put on at the Southampton Arts Festival this spring, as will a play by Diana. Diana has also begun to teach Stony Brook undergraduates.

"I'm writing plays. I'm writing everything," says Diana. "Wonder where I got that idea."

"Think you want to be a playwright?"

"I never want to do just one genre," she says. "And I don't want a real job. I don't want to be real."

"How come we didn't discuss playwriting?" asks George.

"There wasn't enough time. And I don't know much about plays."

"You write them," says Suzanne.

"That's what I mean." I taught a playwriting class some years ago, which went okay but nothing great. One thing

worked. I gave my students an exercise that emerged from a conversation I'd had with Wendy Wasserstein. Wendy had said that she knew she was really into the writing of a play when she had created a third character. I had my students set up a situation consisting of two people. Once they had done that, I asked them to introduce a third character, to see how things were shaken up. We also discussed the rhythm of the action of a play, and the odd fact that in dialogue, no one's really speaking to anyone else. But that was about it. Most of the class was spent with the students simply enjoying one another's plays.

"How's teaching going, Kristie?" She teaches a "developmental" class at her community college. Ana is amused by the euphemism. Kristie says she has to go over assignments again and again, "and still they come up after every class and say, 'What's the assignment?'" It's clear that she is very good for the students by whom she is less exasperated than tickled. "There's a navy vet in my class. He sat next to a girl who said not a word to him for the whole semester. On the last day, she looked at him. 'You're like older, right?' she said. 'And you're in the army or something? You do drugs?'"

Kristie and Diana trade funny teaching stories. Ana tells of having a dinner party where, scared to death, she found herself preparing dinner for the greatest cook in Europe. George tells us he used to be a food critic. "I weighed a hundred and ninety pounds before that." He laughs. "The job did me in."

"Out," says Suzanne.

Like Diana, Sven is writing in new and different forms. "I used to think I was a short story writer," he says. "Now I'm finding stories the hardest to do."

Donna has sent out four stories in the past year, all rejected, though she received an encouraging note from the editor of *National Geographic*. "Is that good?"

"You bet it is." I start to tell her not to be discouraged by the rejections. But one look tells me that's unnecessary. She's hooked. They all are.

"May we talk about stuff you never let us talk about in class?" says Sven.

"Like what?"

"Things writers do other than write."

"Like drink?"

"Like readings. The thought of giving a public reading of anything I wrote scares me to death," says Veronique.

"I love going to poetry readings," says Suzanne. George and others nod. "Poets are so crazy. You can see it in their faces. It's great."

"I think they're sexy," says Inur. "Not like prose writers." She indicates me.

"Do you think poetry readings are better than readings by novelists and essayists?" Jasmine asks me.

"Probably, if the poet is a good reader, like Billy Collins, or Dylan Thomas. Lowell was a terrible reader, and if you've ever heard recordings of the vaguely British,

dry-as-dust voice of T. S. Eliot, you'll wonder what happened to his hometown of St. Louis."

"Poetry readers are easier to listen to," says Ana. "Because the readings come in short bites."

"Did you ever hear Billy's joke about imagining Dante at the lectern as he was about to give a reading? Dante says, 'I'll just read three poems.'" I tell them to be careful about reading their work too well, that mistakes can be covered up by hypnotic voices. "Your silent reader won't cut you as much slack. You should have fun with readings, poetry or prose, because the audience can't really understand everything it hears. You might as well make the most of it. Years ago I saw a cartoon in a magazine, in two frames. A writer bends over his book at a reading. He looks up at the audience and says, 'Oh. You mean *aloud*!'"

"I'd like to talk about the writing life," says Diana.

I am about to say, "What life?" but I hold my tongue. "You mean things about the way writers live? I have no idea how you should live."

"Yeah," says Donna. "Let's get down to all that stuff you hate to talk about—editors, publishers, advances, agents. Fame!"

"Let's get real," says Diana.

"A few minutes ago you said that you didn't want to be real."

"Come on," says Jasmine. "We're not in a classroom now. You won't lose your virtue."

"Everyone sinks to the lowest level at Robert's," says Robert, raising his shot glass. "It's a regular joint."

"All right." I sigh dramatically. "You want to know about agents? I cannot tell you how to get one. My agent, Gloria Loomis, has been with me for thirty-four years. When I started out writing for *The New Republic*, Gloria read an essay I wrote and called to ask if she could represent me. I was so flattered, I think I said 'Huh?' or 'Wow!'—something sophisticated like that."

"So we should all get jobs on *The New Republic* and wait to be discovered?" says Diana.

"Yes."

"Why does everyone look down on agents?" says Inur.

"Because they are indispensable, like dentists and lawyers. And they're subject to the same jokes. They deal with all the things you don't want to touch."

"Money!" says Donna.

"Money."

"What about editors?" asks Ana.

"You have to be lucky, and I've been lucky there, too. There are very few real editors these days. Most people who call themselves editors merely acquire books or authors. They don't get into the texts, and by that I do not mean line-editing or copyediting. Great editors determine what it is you want to say—"

"What is this about?" says Veronique.

"Exactly. Great editors become their authors. They

question what you have written the way you would yourself, had you come up with the question. It's a weird process for a writer. First you resist a correction or a suggestion, thinking, 'That can't possibly be right.' Then you realize that your editor has seen your intentions more completely than you have. They will tell you what you meant to say. They will point out what's missing, or whether you need a new direction, or that you ought to go further in the direction you've chosen."

"Some writers say they don't need an editor," says Sven.

"Not the good ones. In the very least, an editor saves your ass. I've never known a good writer who did not profit from the hand of a first-rate editor. Sven? You have any more questions?"

"This may sound funny," he says. "But is there a particular kind of place a writer should live? Is one location or another better for one's work?"

"It doesn't matter where you live. Country, city, suburb—all three have been home to great writers. It doesn't matter how much money you have, either, though try to live within the general vicinity of your means. You don't want money to drive your artistic decisions, and poverty will do that to you. Neither does it matter if you hold another job while you write, especially if you need to pay the heating bill. Chaucer was a civil servant, Keats and Joyce were medical students. Wallace Stevens an insurance man. Melville a customs

inspector. Nathaniel West was the night manager in a cheap hotel. Frank O'Hara worked at the ticket counter in the Museum of Modern Art. It is common practice to advise young writers to take jobs that have nothing to do with reading and writing, so as to create some space between the real world and the imagined."

"We've heard that a lot," says Inur.

"But being a book editor didn't get in T. S. Eliot's way. And writers such as Doctorow, Alice McDermott, Ann Beattie, and Joyce Carol Oates continue to teach writing and literature. The trick is to find your place in the world—your town, your home, your room—which is usually achieved by hit-and-miss. After that, the trick is to recognize what you've got once you've got it, and not to let success or ambition lead you away from it. It took me thirty years to realize that where I wanted to be was in a lumpy white chair positioned at a forty-degree angle from a window looking out on a pine tree in front of my house."

"What about your friends?" asks Inur. "Should writers hang with other writers?"

"Or we shall all hang separately," says George.

Many young writers seek the company of other young writers because they share a common world of gripes, celebrations, professional problems and interests, and because companionship lessens their loneliness. Dr. Johnson had his circle, Keats his. Both groups consisted of artistic folks such as Boswell, Joshua Reynolds, and

Leigh Hunt. Hemingway chose a rougher crowd made up of boxers, big-game hunters, and Gertrude Stein. These little conventions are usually pictured in convivial situations, like weekly dinners in picturesque taverns. The participants are shown being witty and happy together, though I saw a black-and-white photo of Joseph Heller, James Jones, Truman Capote, and others drinking together in a Hamptons dive, each seemingly competing for the title of "Grimmest Face in America." Yet for Johnson, Keats, Hemingway, or any first-rate writer, the idea of clubby companionship is nearly always a pretense. History's more amiable writers, such as Oliver Goldsmith and Charles Lamb, were anomalies. And the most famous American circle, the Algonquin Round Table in New York, had no first-rate writers at all.

"At the outset of your careers, you will probably enjoy the company of others for a while, up to the point that you know for certain what your life's subject is, and your craftsmanship has risen to meet it. Then you will notice that you are increasingly disinclined to be in contact with your old friends, even the most beloved. Your husband, wife, partner, whoever, will constitute all the social life you need, and surprisingly little of that. In the end, you will find yourself glorying in that same solitude you sought to avoid at the start."

"Do you think our group could become a circle of writers?" asks Kristie.

"First become writers."

"Will we all turn out to be disagreeable old men like you?" asks Jasmine.

"If you're lucky."

"I think you're suggesting that we shouldn't get married or live with someone," says Kristie.

"Too late," says Suzanne, turning to George.

"What sort of person would want to live with a writer?" asks Veronique.

"A patient one."

"Should a writer marry another writer?" asks Jasmine.

"A patient one"—and before they tell me that my wife must be very patient, I suggest we order dinner.

For three hours more we sit and enjoy one another's company. We drink. We overeat—lobster bisque, polenta, lamb, salmon, rib eye. The talk glides from Shakespeare and Jane Austen to Steven Seagal and Nicolas Cage and Tiger Woods, and a guy who delivered pot-laced brownies to the office where Inur once worked. I sit back and listen. After two shots of Jameson's neat, everything can look lovable, but cold sober I would love this group, especially for their affection for one another. Kristie asked me if they might become a literary circle. They are something better—a circle of friends.

Diana looks up at me, sensing we are about to call it a night. "Is there anything you haven't told us?" she asks. "Last chance."

"That's hard to imagine," says Suzanne to the others. "He's talked too much. Yak yak yak."

"Well, there is something I might have mentioned, but it's difficult, so I didn't think you were up to understanding it. Anyway, it's too late now." I get my coat, and move toward the door, accompanied by a chorus of boos. We hug, and we part. I decide to toss in my parting shot from long distance.

TO: My ungrateful students

RE: An inspirational letter

Oh, read it anyway. You may not need this postscript as much as I need to give it to you. But there *is* something about writing I haven't told you, in part because it smacks of the sentimental and abstract—two of the monsters I've hoped to drive from your work. And yet, if I fail to give you this final piece of information, if I let you stride toward that desk of yours thinking that good writing consists only of precision and restraint, and of the right words in the right order, and using anticipation over surprise, and imagination over invention and the preference of the noun to the adjective and the verb to the adverb, and a dozen other little lessons, however helpful they may be, you may conclude that once you've nailed these ideas, well, you're a writer. Well, you're not. Not yet.

Lewis Thomas said that there's an evolutionary ten-

dency on the part of the species to be useful. He told me this in 1993, when I was doing a series of interviews with him for a piece for the *New York Times Magazine*. I had known Lewis a little before that, and like millions of others, had much admired his *Lives of a Cell* and *The Medusa and the Snail* and his other books that, thanks to his generous and observant eye, brought science to philosophy with a rich, joyous appreciation of the world. He was dying of lymphoma, and I asked him, since he had shown so many people how to live, if he might talk about how to die. This is what we discussed as we sat in his apartment on Manhattan's Upper East Side, week after week, in the mornings with the sun blasting the white walls and his wife Beryl nearby and his Yorkie at his feet—the imponderability of death, his wish not to be reincarnated because he'd had so good a life the first time round, his disbelief in an afterlife, which was undercut by his conviction that nothing in nature disappears. But in the fall of 1993, as his stern and handsome face was growing paler and bonier, he paused in mid-sentence and said, "You know, I really don't want to talk about death anymore. I'd rather talk about life, how to live." He said he thought that nature was basically amiable—good-natured. And that the proof of nature's amiability was usefulness. He cited female beetles in an area near Houston, Texas, who lay their eggs in a slit that they cut in a branch of a mimosa tree. The eggs develop and crowd out the tissue of the branch, and eventually

the branch falls, but not until the eggs hatch. This pruning keeps the mimosa trees healthy. The trees are useful to the beetles, the beetles are useful to them. "There's an art to living," Lewis said. "And it has to do with usefulness. I would die content if I knew that I had led a useful life."

Toward November, Lewis weakened, just about the time my essay came out in the *Times*. For the next ten days or so, hundreds of letters from Lewis's readers came to the *Times* or to me directly, saying how grateful they were to him, how much he had taught them, and how sad they were to learn he was dying. He read many of these letters, and when he fell into a coma, I continued to read them to him in the hospital. You never know. When he died not long after that, there could be no question in his mind that his life had been useful.

You see where I'm going with this. For your writing to be great—I mean great, not clever, or even brilliant, or most misleading of all, beautiful—it must be useful to the world. And for that to happen you must form an opinion of the world. And for that to happen you need to observe the world, closely and steadily, with a mind open to change. And for that to happen you have to live in the world, and not pretend that it is someone else's world you are writing about. A tendency of modern literature is to claim, "We must love one another or die," or "be true to one another," or "only connect." Sweet as such sentiments may be, they give up on the world and

imply that the best way to live in it is to hide from it in one another's embrace. Instead, you must love the world as it is, because the world, for all its murder and madness, is worth loving. Nothing you write will matter unless it moves the human heart, said the poet A. D. Hope. And the heart that you must move is corrupt, depraved, and desperate for your love.

How can you know what is useful to the world? The world will not tell you. The world will merely let you know what it wants, which changes from moment to moment, and is nearly always cockeyed. You cannot allow yourself to be directed by its tastes. When a writer wonders, "Will it sell?" he is lost, not because he is look-ing to make an extra buck or two, but rather because, by dint of asking the question in the first place, he has oriented himself toward the expectations of others. The world is not a focus group. The world is an appetite waiting to be defined. The greatest love you can show it is to create what it needs, which mean you must know that yourself.

Everything contains significance. But some signifi-cances are more equal than others. The writers whom we agree are the great ones deal only in matters of proved importance. They are great because their sub-jects and themes are great, and thus their usefulness is great as well. Their souls are great, and they have had the good sense and the courage to consult their souls before their pens touched paper. Go and do likewise.

And do not tell me that greatness lies out of your reach, because that would mean your soul is out of your reach. The trouble with much writing today is that it has been fertilized and nurtured in classrooms like ours, where the elements of effective writing have been isolated and studied in parts. No teacher of writing, myself included, dares speak of the subterranean power available to every writer, if that writer will but take the time to brood on the matter and unearth it. In a way, you and I have been in a conspiracy against each other. By emphasizing the apparent this and that about writing—this verb, that line—we have been ignoring the invisibilities that are the source of greatness in you. We dwell on style. I cannot tell you if Swift or Cervantes was a great stylist. The lesser excellences of great writers rarely occur to us, because their works are overwhelming. When most modern writers come in for our praise, it is because of their little tricks or little twists. When Homer, Shakespeare, Milton, George Eliot, or Chekhov are recalled, it is as if tidal waves are washing over us. We cannot catch our breath. If I have taught you only to write so that your contemporaries may say nice things to you, I have failed you. I should have been teaching you that the one goal you must aim for is the stunned, silent gratitude of history.

I have known several great writers well and have met several others. All have in common a certain inno-

cence of mind that allows them to observe life openly and with a sense of fair play, though not without judgment. Whatever they write, a sonnet or a satire, arises from their liberalism of spirit, which is a restless spirit. They also cultivate their innocence and rediscover the virtues they believe in every time they sit down to write something new. They may surprise themselves by the insistence of their own high motives and values. Picture Dickens working out his labyrinthine plots on his long walks around London, forever returning to the child of his imagination—Oliver Twist or David Copperfield or Ebenezer Scrooge as a schoolboy—whom he could trust to bring him back to a defense of the just, the right, and the good.

It is your soul I am talking about, I'll say it again. And if, upon examination, you find your soul inadequate to the task of great writing, then improve it, or borrow someone else's. Commencement speakers are forever telling you to be yourself. I say, be someone else, if that other self is superior to yours. Borrow a soul. I am not in the least being facetious. In *The Real Life of Sebastian Knight*, Nabokov says that the soul "is but a manner of being," not a constant entity. Dissatisfied with the makeup of your old soul? Trade it in. But always trade up, and make the new one a great soul, capacious, kind, and rational, for only a soul of such quality and magnitude will produce the work you aspire to. If there is one

lesson I hope to have given you in our classes, it is that your life matters. Now make it matter to others.

You must write as if your reader needed you desperately, because he does. If, as Kafka said, a book is an ax for the frozen sea within us, then write with that frozen sea in mind and in view. See your reader, who has fallen through the ice of his own manufacture. You can just make him out, as he flails in slow motion, palms pressed upward under the ice. Here's your ax. Now, chop away and lift him up by the shoulders. And what do you get out of this act of rescue? You save two people: your reader and yourself. Every life is exposed to things that will ruin it, and often do, for a time. But there is another life inside us that remains invulnerable and glimpses immortality. For the writer that life exists on the page, where it attaches itself to every other life, to all the lives that have been and will be.

From time to time, during the months we have been together, it may have seemed that I expected too much of you. In fact, I have expected too little. To be the writers you hope to be, you must surrender yourselves to a kind of absurdity. You must function as a displaced person in an age that contradicts all that is brave, gentle, and worthwhile in you. Every great writer has done this, in every age. You must be of every age. You must believe in heroism and nobility, just as strongly as you believe in pettiness and cowardice. You must learn to praise. Of course, you need to touch the sources of

your viciousness and treachery before you rise above them. But rise you must. For all its frailty and bitterness, the human heart is worthy of your love. Love it. Have faith in it. Both you and the human heart are full of sorrow. But only one of you can speak for that sorrow and ease its burdens and make it sing—word after word after word.